Art Classics

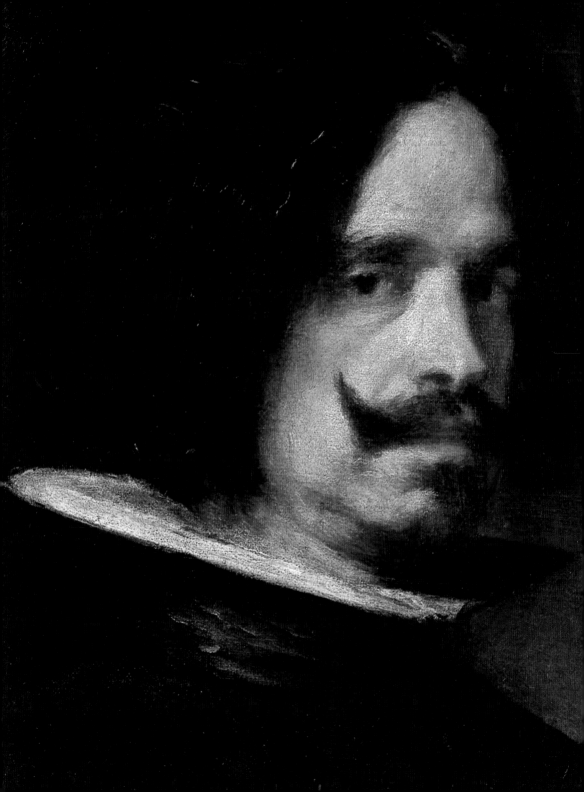

Art Classics

VELÁZQUEZ

Preface by Miguel Angel Asturias

ART CLASSICS

VELÁZQUEZ

First published in the United States
of America in 2006 by
Rizzoli International Publications, Inc.
300 Park Avenue South
New York, NY 10010
www.rizzoliusa.com

Originally published in Italian by
Rizzoli Libri Illustrati
© 2004 RCS Libri Spa, Milano
All rights reserved
www.rcslibri.it
First edition 2003
Rizzoli \ Skira – Corriere della Sera

2005 2006 2007 2008 2009 /
10 9 8 7 6 5 4 3 2 1

Printed in China

ISBN: 0-8478-2812-3

Library of Congress Control
Number: 2005933794

Director of the series
Eileen Romano

Design
Marcello Francone

Translation
Timothy Stroud
(Buysschaert&Malerba)

Editing and layout
Buysschaert&Malerba, Milan

cover
Las Meninas
(detail), 1656
Madrid, Museo Nacional del Prado

frontespiece
Self-Portrait
(detail), *c.* 1650
Valencia, Museo de Bellas Artes

The publication of works owned by
the Soprintendenze has been made
possible by the Ministry for Cultural
Goods and Activities.

© Archivio Scala, Firenze
© Lessing/Contrasto, Milano

Contents

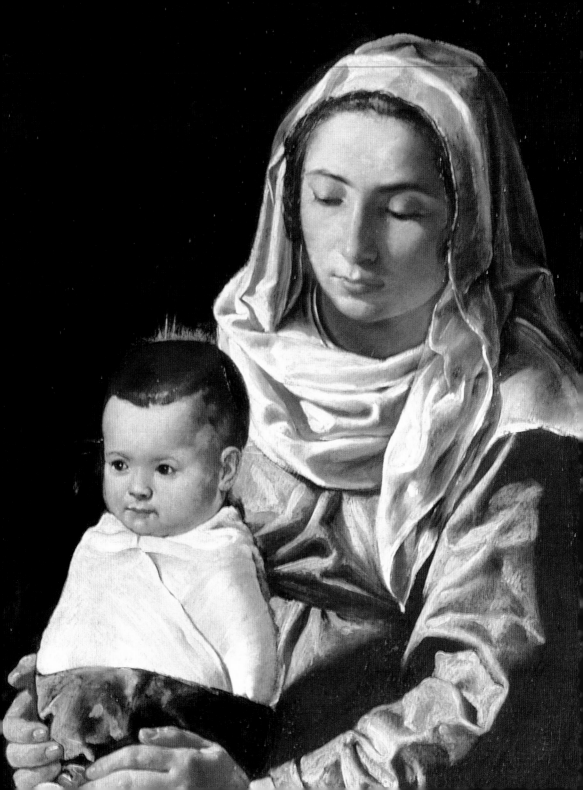

Velázquez Beyond Painting
Miguel Angel Asturias

In this forum it is not my intention to discuss the technical novelties, stylistic relationships, and dazzling presages of modern pictorial sensibility that can be found, and which have already been learnedly studied, in Velázquez' painting. Instead, I wish to point out his symbolic or prophetic quality, and his ability to interpret the greatness, mystery, power, and decline of one of the most extraordinary and enigmatic countries in Europe: Golden Age Spain during the Peace of the Pyrenees treaty.

Naturally every great artist is in some way the retrospective epitome of his moment projected into the future, and in this Velázquez is exception; on the contrary, his role as court painter placed him firmly in the middle of the most important historic events of his time. One searches in vain, however, in the tranquil and protected flow of his life, upset only by his difficult ascent of the *cursus honorum*, for a direct echo of the troubles and warring turmoil that was to drain, during that same period, the great power that had discovered and colonized the West Indies, turning it into an economically exhausted, politically marginalized, and culturally isolated nation. However, Velázquez's curriculum is significant in that it reflects a series of national obsessions and myths that ruffled the Spanish sense of delicacy in their absurd obsessions with courtly decorum, ancestral nobility, and the quest for the supreme dignity of investiture as a knight of Santiago.

For Velázquez the court and Philip IV were not the happy or chance sinecure of a great artist who might elsewhere have been able to find a field richer in emotional depth and transformation, nor was it a gilded cage for his rich, complex genius; rather, it was an appropriate arena for his talent

The Adoration of the Magi (detail), 1619 Madrid, Museo Nacional del Prado

7

and his personal inclinations. It is unsurprising that his relations with the king were for both parties always based less on devotion and admiration than a mutual elective affinity and an identical weltanschauung.

Specialists of Spanish painting have familiarized us with his technical and thematic advances and the revolutionary inventiveness of his stylistic motifs; this essay is not aimed at those who are interested in painting from a technical standpoint, rather at those who consider these same problems from a more general, cultural, and historic perspective. Starting from this premise, it is interesting to establish to what extent Velázquez interpreted the historic moment in which he lived and with what means of expression. Bear in mind that he was alive at the same time as immortal figures such as Cervantes, Calderón, Lope, Quevedo, Góngora, Gracián and, outside of Spain, Descartes, Spinoza, and Leibniz, whose revolutionary philosophical and cosmological theories managed to force their way into the Iberian peninsula.

To fully appreciate the importance of Velázquez's artistic message, we should remember the memorable innovations that the Sevillian—as he was called by one and all—introduced to Spanish painting in the first half of the seventeenth century. Meanwhile, let's focus on his city of birth, Seville. As is known, at that time Madrid was still a city of no particular importance that was promoted to the rank of capital by Philip II. It was only later, during the reign of Philip IV, that it became the centre of Spanish culture and politics, partly due to the assistance and advice of the artist, who promoted, among other things, the most significant purchases of works of art (which later ended in the collection of the Prado) and the notion of new royal residences, such as the *Retiro*. During this period Seville continued to be the spiritual and economic hub of the Iberian peninsula, and it was here that the group of the three great Spanish artists—Zurburán, Velázquez, and Cano—who would later enrich European art with completely new formal values and content, formed.

Velázquez immediately defied the rigid academic canons seen in official painting, represented by Pacheco, in particular with regard to the necessarily ideal characteristics of the iconography. These were guidelines, or rather precepts, and in those times it was simply not permissible to take lightly provisions that were less related to problems of an artistic nature than to theological and moral casuistry. Velázquez broke with the earlier tradition and introduced to Spanish painting the most humble and quotidian scenes. In doing so he did away with the incredible arrhythmia that existed between the literary world and its themes, as well as the themes that were fashionable in the fine arts. Thanks to such works as the *Water-Seller*, the *Topers,* and even his last creations (*Las Hilanderas*), Spanish painting was finally invaded by direct observation as part of a fresh, natural approach that lay outside the strictness created by ideal conventions and theoretical program. And this was achieved without falling into the trap of being picturesque or indulging in genre painting, but with the insight and authority of one able to recognize the essence of people and objects. In his Seville period he painted vivid moments taken from the world of the Spanish picaresque and scenes that recall the works of Mateo Alemán, Hurtado de Mendoza, and Cervantes.

Another of Velázquez's great inventions was the landscape. Before him the other truly great 'Spanish' painter—El Greco—considered the landscape to be no more than a mere interpretation of a spectral city in the bluish light of an imminent storm. Naturally, Spain had painters that specialized in landscapes, but the backgrounds of their paintings never blended with the theme in the foreground in the same way that Velázquez succeeded in doing in the vast Castilian spaces that he painted.

However, this did not make Velázquez a landscape artist in the Flemish manner. He took no pleasure in painting the landscape by itself, but used it to support and complement his portraits. His landscapes spread right across the horizon, accentuating the totality of his vision and enveloping the greatness of the figures. The artist's portraits of hunters—above all those of the

Cardinal-Infante, the king, and Prince Balthasar—are not made hunters just by their clothing, but by the wild and rough terrain that surrounds them, the fearful presence of hares and partridges, and by the oaks which, immobile, function as the landscapes' magical axes. It was from this innovation in the treatment of the landscape (an innovation in Spain at least, since the Venetians had already conceived it in the same way; remember that the Sevillian had the greatest admiration for Titian and Veronese) that the perfect fusion between figure and setting arose. This development meant that the space around the figures became an irradiation of the figures themselves, as their exact and perfect receptacle. Ortega y Gasset wrote very shrewdly that "in Velázquez the aerial ambience derives from the figures themselves and not from their outline, space or sphere."

When we speak of a perfect and magical fusion with the setting, the reference to *Las Meninas* comes immediately and spontaneously to mind. According to Palomino, Velázquez's most famous and trustworthy biographer, the excellence of the painting resides in its marvellous realism. He underlines the extraordinary quality of "a typical Habsburg interior [...] with a floor [...] on which one can almost walk." Today it appears exactly the opposite. Never as much as in *Las Meninas* has the perspective of a painting been conceived in such an unreal manner, or with a greater power of invention. The world of the *Meninas* is enchanted, like a large flower that has at its centre the Infanta and her maids-of-honor. The apparent objectivity in this miraculous whole was not achieved by Velázquez through a construction of solids, spaces, and objects so real they can almost be felt, but by elaborating this tiny universe as light and reducing it to the state of unstable luminescent particles. When we view the painting from close up, we only see dots in the void and broken, disconnected shafts of light. In the canvas, these create an outline that clings to the figures like a sort of spatial covering. The objects are set in space and palpitate with light. In this manner Velázquez succeeded in expressing the infinite.

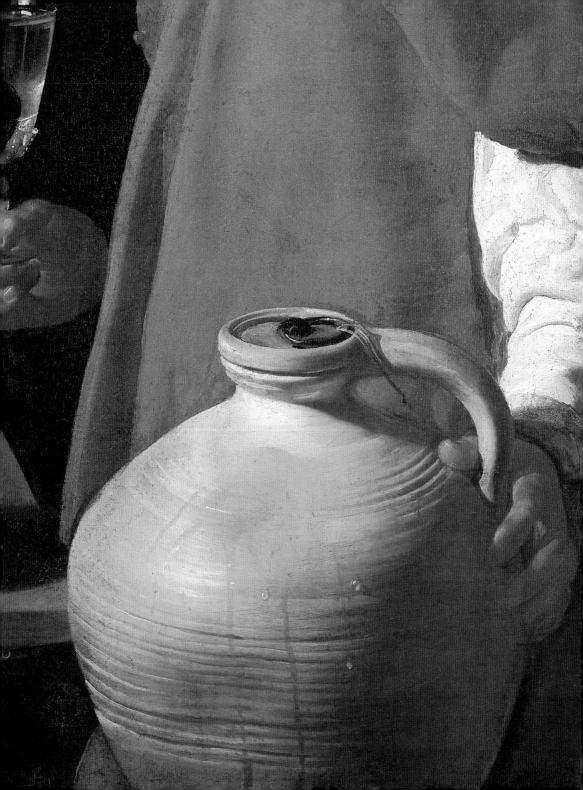

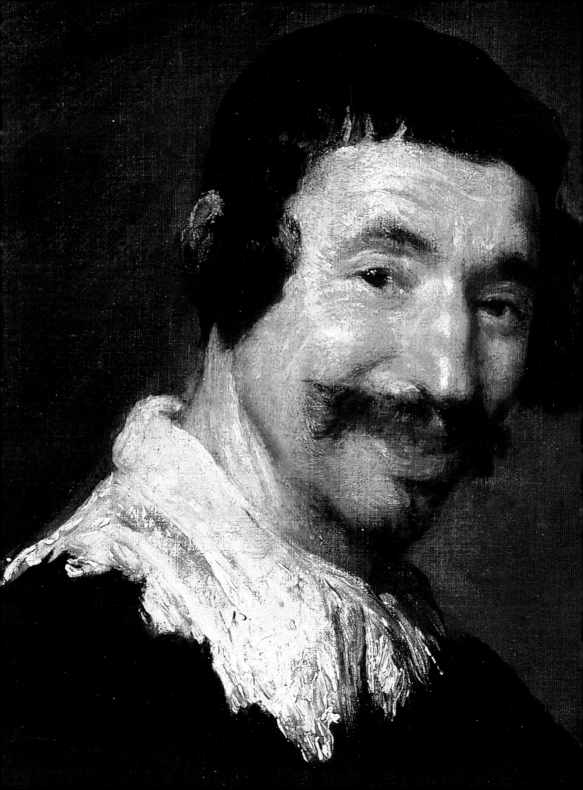

But Velázquez's greatest contribution to the universal aesthetic sensibility is the sentiment that enshrouds all his creations like a light tunic: melancholy. Further on we shall see how Velázquez interprets, in plastic terms, feelings of anguish and themes central to the Spanish culture of his time. No other contemporary artist or thinker created a more moving farewell to the empire, a farewell bade with head held high but also with a saddened spirit. His recognition of the empire's decline is expressed in a painting without contrasts or melodramatic gestures, and a prevalence of grey and silvery tones that seem to represent the stoic feebleness of the House of Austria. Melancholy is Velázquez's spiritual dimension, and he uses it to ennoble his figures in an indefinite way, imbuing them with a disdainful remoteness and resigned acceptance of the role that has befallen them to play in the world. His portraits of Philip IV show the sadness of a fading twilight like the one that befalls the stars, a phenomenological expression of an aristocratic form of sorrow, a sorrow that rejects compassion.

This melancholy creates an insuperable void between the sitter and the observer. The princes, princesses, and the clowns, the leading characters in Calderón's play *The Great Theatre of the World*, remain etched in our memory much deeper than any inspired feeling of pity could achieve. Even though his court portraits are not accompanied by any scenographic ornamentation, the king and his courtiers seem to us much more privately remote and superior than the very theatrical contemporary paintings of Louis XIV of France due to the imperceptible veil of haughty sadness Velázquez confers on his sitters, an atmosphere that seems to represent the royal declaration of an empire in decline.

The Spanish princes and princesses, the Infantes, and the queens and kings are all crowned by this subtly tormenting sentiment in their immortal pictorial lives, and are the mysterious version (in illustrative terms) of a court that converted its characters—whether protagonists or mere instruments in the procedural organization of the state—into shadows of themselves. It

was a court in which both characters and events were drained of their life-blood and vigor, leaving only the pomp, etiquette, and pride showing through.

Velázquez's technical approach—from his early periods in Seville and Madrid (grey), his first trip to Italy and subsequent stay in Madrid (ochre), and his second trip to Italy and final years—progressively expressed, in a perfect and purified form, these otherwise ineffable sentiments. His touch became airier and more fluctuating, fluid and light, almost as though each brushstroke were unrelated to the underlying drawing. His last paintings—those that seem burdened by the nightmares of Philip IV faced by his failures in Europe and America, the miserable disgrace of the Count-Duke of Olivares, the Catalan rebellion, and the separation of Portugal from the Spanish crown—present us with no more than larval masses, striking allusions, creations through the decomposition of matter. It was only through a technique like this that he could paint during such a moment in history, one so unsure of the present, in a period of such transition and defeat. Yet Velázquez's melancholy represents something more than the stoic acceptance of an unhappy destiny. The drama is not depicted in obvious fashion because the Spanish rulers seem to be beaten not by the hand of man but by the implacable forces that govern the world, which one can only oppose with a proud and solitary resignation. Nevertheless, the inescapable ring of solitude that encircles the king and princes in Velázquez's portraits has another, more complex, origin. It is rooted in the atmosphere of bitterness and disappointment so significantly present in the moralistic and philosophical literature of seventeenth-century Spain. It represents mistrust in the goodness of humanity and a vision of the world as a dark field of ingratitude, treachery, and deception.

All the writings of Baltasar Gracián are overshadowed by a pessimism that generated obsessions with two-faced monsters. His aphorisms seem the best defense against a world thought to be necessarily and fatally

dangerous. Nothing is more desolating than Gracián's conception of the world, where everything "is an amphitheater of monstrosity."

In the works of Francisco de Quevedo, profound hostility to human society arises from a pessimism that at times takes on the highest nobility when faced by the troubles of the world. In Quevedo's writings, however, which were contemporary with Velázquez's output, one can perceive an unusual parallel with the themes and approach taken by the Sevillian. Quevedo also started by describing the most unsophisticated aspects of the world around him in situations of the harshest and most disagreeable realism. He used direct and aggressive language but employed a technique of linguistic chiaroscuro that was the equal of the *tenebrismo* used by Velázquez. Though Quevedo wrote in a satirical, biting style all his life, with the passing of the years his prose became more attenuated and tranquil, almost plush, and the same thing happened to the painter: by the end of Velázquez's life his palette had become more serious, greyer, and imbued with human compassion.

During the Baroque, all the arts and styles became more extreme in their means of expression. Only Velázquez provided an undramatic elegance, one frozen into immobility by his contemplative approach. Action is withheld as though by a superior sense of *cortesanía* (chivalry), and his figures seem to reflect on the collapse of the greatness of the Spanish empire without resistance. All these aspects—cosmic and measureless—are depicted without emphasis, without urgency, and his works are dressed in the serene melancholy that always accompanies decline. The fleetingness of the splendors and images painted by Velázquez is, in a certain sense, also the pictorial exemplification of another leitmotiv of the seventeenth-century Spanish cosmic vision: that of the transitoriness and impermanence of all things. In one of his immortal verses, Calderón says that "life flows between two doors: the cradle and the grave."

Nothing exists in itself. Human beings are nothing more than ghosts, oneiric forms dreamed up by themselves. Calderón's *Autos sacramentales* are

like a single immense *danse macabre.* Velázquez's works never reached the same stage because everything he painted is always bathed by bright morning light, but even there, behind all that brightness, lies the shadow of something in the process of extinction. His paintings always capture a fleeting and miraculous moment of life but, standing before them, we are aware that the minute that follows in each scene will be dominated by another visual and emotional world, and that the pictorial magic that animates his creations dies at the same instant as its epiphany, killed by its own splendor.

Velázquez had the good fortune to experience and interpret an age that was congenial to his art. If he had lived during the previous generation, his brush would perhaps not have produced living forms totally lacking in transcendence, just workshop formulas and theoretical program. His painting is distinctive of a moment in the spiritual history of Spain and Europe, one in which all idealisms had faded away; indeed, whether he painted a fruit, a jug, or a Saint John, it was depicted with the same absence of spiritual or emotional irradiation. Perhaps Velázquez's great revolution lay in the fact that for him there were no classical categories of beauty or ugliness. He did not counter the ideal representation of beauty with ugliness, as the Romantics so controversially did later on, but simply reproduced, without pity, the volumes he saw—whether a low-class tavern, dwarves, clowns, or princes—without having any say in the degrees of beauty or ugliness that these volumes had in themselves. With the impassibility of a baroque scientific spirit, or of an artist with profound cosmic needs, he depicted his creations in their own ambient integrity, in their own spatial and luministic relationship with other beings.

It is very surprising to see the perfect agreement between Velázquez and the scientific and cosmological theories of the time. His painting was not only revolutionary from a technical viewpoint, compared to its Italian equivalent, but embodied, without pedantry or cold intellectualism,

17

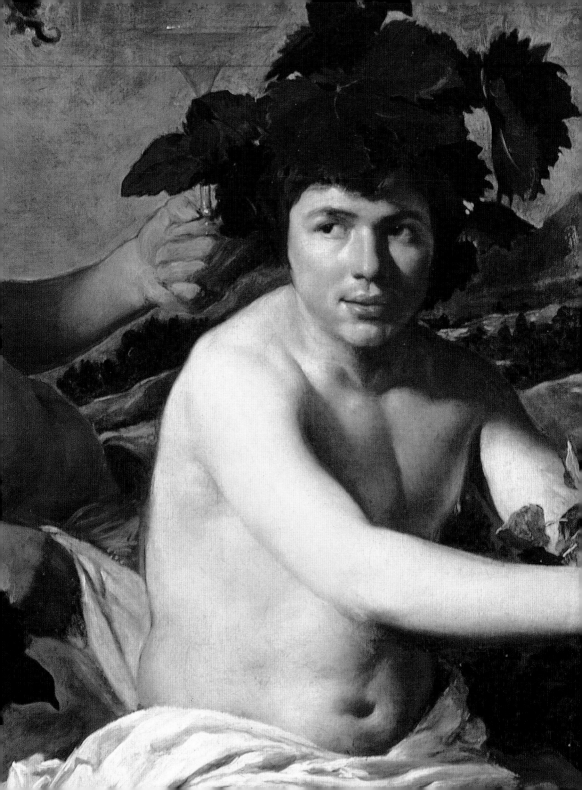

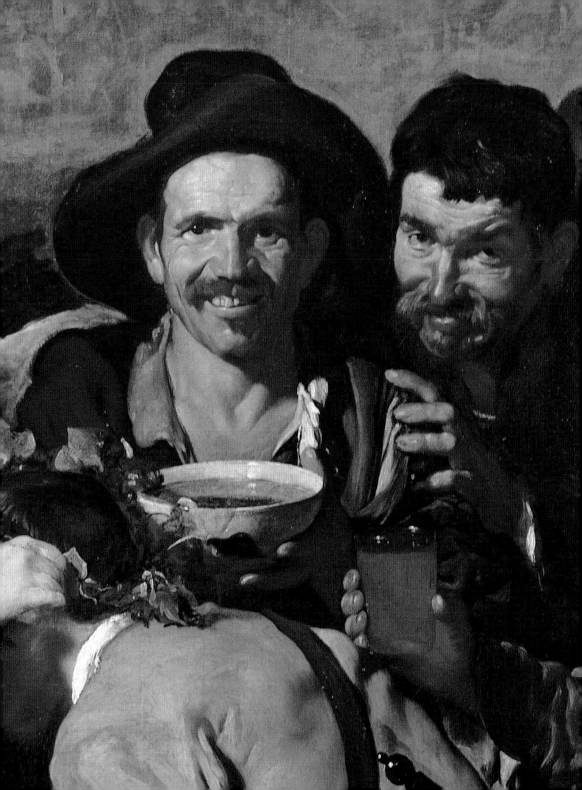

the most modern and innovative philosophical tendencies of the period. As is known, that subjectivism began with Descartes: this was a way of uniting the individual with an overall interpretation of the universe in a manner that still dominates thinking today. Reality was conceived as pure appearance, whereas the first and last source of truth resides in the human soul. The warmth, odor, and color of objects do not exist in themselves but are simple modifications of the soul; bodies are not as they appear to us.

Velázquez's art set out from a solid faith in the objective existence of things, in the unshakable belief in the reality of the world that surrounds us. Things presented themselves to him with the colors that they themselves emitted by their very nature and quality, with temperature and brilliance being autonomous and untransferable. This way of understanding and painting nature corresponds to his early days in Seville and first stays in Madrid and Italy, but with the passing of the years the objects in his paintings take on a more malleable and ambiguous appearance, more open to the two large universes that man is able to contemplate: that of the tangible world and that of the soul.

Gradually, those themes and objects that previously had seemed to exist in their hard, visible, physical reality appeared to subsist only as a result of the atmosphere and the artist's emotions. In his final and increasingly appealing technique, Velázquez's attention was focused purely on the appearance of objects, which he endowed with an existence as real objects by the magic of his touch. Perhaps Velázquez' most surprising legacy resides in this passage from an objective art to a totally subjective one. This transition takes the artist right into our contemporary sensibility—not just on a pictorial level, but also an existential level.

After this stage, which was dominated by the Cartesian philosophy of *res extensa*, he graduated to conceptions of space and time that had originated with the thinking of Leibniz and Newton. The sequence of all the subjectivisms and techniques that have followed one another until the present

day was thus magisterially opened in a rather closed style of painting. This can be seen very clearly in the last of his works, which are fluid and porous, and open to the transient existence of objects. The forms that he created flee from the canvas, and exist the frames to continue their existence in our awareness and memory.

It is as if we were aware of their hurried flight towards dissolution, as though they were subject to the same temporal process as other living entities. From this moment on, the space-time continuum becomes the major feature of Velázquez's work, and is seen in his forms that project not just towards the back of the painting (as in his earlier periods) but also towards the future. And it is here that we discover another of the secret reasons for the melancholy in the artist's works: his figures are full of life, even cheerful, but they lodge within them the bitter pill of death. The *menina* Isabel de Velasco, the immortal figure to the right of the Infanta, died three years after the portrait was painted. However, if we look closely at her figure and the scene as a whole, we notice that they are both overshadowed by a winged spirit of decline that validates the future decay of everything depicted in the painting.

Valle Inclán, the great don Ramón, masterfully summarized the art of Velázquez when he wrote, "The great brush of Velázquez, which diffuses all the images in light and distances them in space, covering them once again in a peaceful enchantment, in the same way that memory does when it calls up reminiscences that are distant, as though lost in the hours of time. The Greek artist unites contrasting forms, the Florentine movement, the Spaniard time."

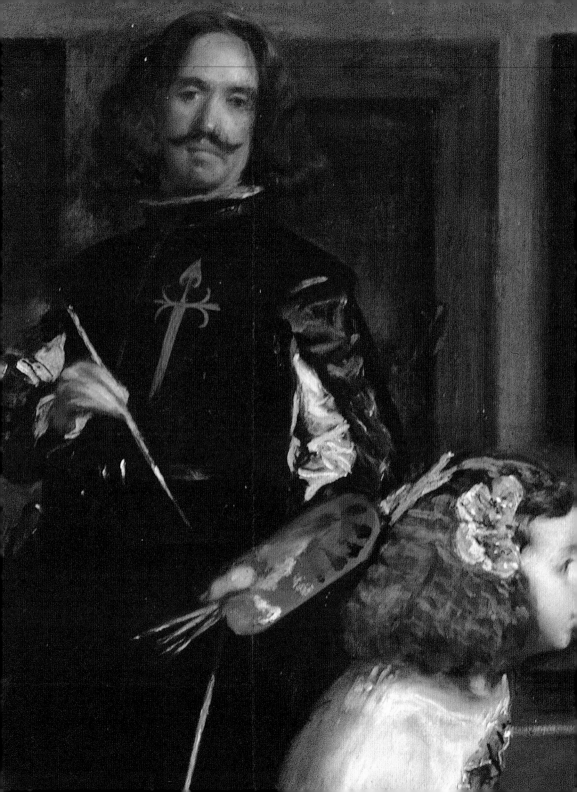

His Life and Art

Diego Rodríguez de Silva y Velázquez was born in Seville in 1599. His father, Joao Rodríguez Silva, was of Portuguese origin and his mother, Jerónima Velázquez, from Seville. Following the Portuguese custom—common also in Andalusia—he took his mother's surname. As was usual for many families arriving from Portugal to settle in Seville at the end of the sixteenth century, it is possible that Velázquez had distant Jewish origins. What is not certain is the nobility of his grandparents, a claim that he later made and on which the artist's biographer, Palomino, insisted, retracing the Silva family tree to the legendary figure of Enea Silvio, king of Albalonga. In any case, this presumed nobility was not to have any particular consequences—economic or social—on Velázquez's life. What was decisive was the stimulating environment into which he was born.

In 1599 Seville was the largest and richest city in Spain, and without question the one with the most open and cosmopolitan atmosphere in the Spanish empire. By royal decree it held a monopoly on trade with America, and this state of affairs had attracted a large colony of Flemish and Italian merchants who stimulated the city's vitality and wealth. In addition to its long-established cultural nobility—the legacy of the humanistic milieu during the first half of the sixteenth century and the bourgeois culture of the merchants that had grown up on the back of American gold and silver—Seville was also invigorated by the presence of pedlars, crooks, and *picaros* on the edges of civil society. Seville's famous prison and its picaresque world appears, with a certain degree of realism, in some of Cervantes' *Novelas ejemplares,* and the whole city was the ideal setting for the plays written by Lope de Vega and Tirso de Molina during Spain's Golden Age.

In this varied and vigorous atmosphere Velázquez began his training at the age of ten. Around 1609 he spent some months in the workshop of Francisco Herrera the Elder, a

on page 22

painter of good taste and artistic talent but who was also well-known for his appalling character; Palomino called him "a strict, pitiless man." His young pupil soon tired of putting up with Herrera's stern temperament and decided to turn to Francisco Pacheco, with whom, on December 1, 1610, he signed a contract of apprenticeship that would last between four and six years. During this period, the apprentice would lodge in the master's workshop, be provided with board and clothing, and not be required to perform any menial tasks.

Pacheco is better known as a writer and Velázquez's master than as a painter; he was a very unusual example of a cultured artist and expert on classical literature. He enjoyed great prestige in ecclesiastical circles and exerted a large influence in Italian academies and Seville's literary coteries of local nobles. An expert in theology, but also a connoisseur of Sevillian humanism, Pacheco was a typical representative of the Spanish Counter-Reformation: a faithful servant of the Church that attempted to defend itself against the Protestant Reformation with intolerant, unquestioning dogma, but also a scholar who had a clear familiarity with the pagan pantheon of Olympus and, in general, with the classical tradition. A man of varied talents, his interest in art was directed at painting, which in Spain was still considered a low-level profession. Pacheco was the author of an important treatise (*Arte de la pintura*, The Art of Painting) published posthumously in 1649 that is an indispensable source for knowledge of contemporary artistic life in Seville and Spain. It provides information on practical aspects—for example, it reveals the persistent influence of religion on the professional life of artists, and provides a look into the daily life of the workshops—but also on theoretical issues; for instance, Pacheco shows himself faithful to the idealist tradition of the sixteenth century and less interested in the naturalistic direction taken in the Flemish and Italian painting of the time.

This was the climate in which the

adolescent Velázquez matured, during the six years in which, in accordance with the strict terms of his contract, he had to remain with his master accepting "everything either said to him or ordered him if it were honest and possible to do." Pacheco taught art "well and fully, …without concealing anything from him."

In the spring of 1617, when his contract expired, Velázquez passed the required exam to practice art autonomously. In an unusual step, when requesting the young man's license to practice, his examiners, Pacheco and Juan de Uceda, asked specifically for Velázquez to have the right to work throughout the kingdom rather than just the customary local authorization. With this document in hand Velázquez was ready to set up his own workshop and, as a master, to enter into contracts to take on apprentices or collaborate with other painters.

On April 23, 1618, the following year, Velázquez, not yet twenty years old, married Juana, the daughter of his master Pacheco, who was moved by the young man's "virtue, integrity, and by the expectations created by his great and natural talent." With Juana he had two daughters, Francisca and Ignacia. The marriage maintained the old tradition, frequent among Sevillian painters, of creating family ties within their profession to consolidate the network of interests that brought them work and commissions. The opportunities that opened to Velázquez were the same as those for other painters of his same age. The painters' clients, who were mostly ecclesiastical, wanted religious scenes, paintings for devotional purposes, monastic cycles, still-lifes, and portraits. An interesting alternative was offered by the study of nature, which was by then also accepted by the Church as a means of taking religion to the common people and combating the intellectual abstraction of the Reformation through direct, richly emotional images.

Velázquez immediately applied himself to aspects closest to the real world, for which he had an outstanding talent. Francisco Pacheco recounts that "when he was a boy he bribed

an apprentice peasant to act as a model for him in various poses and positions, now crying, now laughing, without avoiding any difficulty."

During this period Velázquez managed to improve his rendition of nature, creating volume and the appearance of different materials through the use of the new device of chiaroscuro, for which the genre of still-lifes was an excellent testing ground.

The vigorous cultural atmosphere of Spain's Golden Age induced the artist to develop a taste for pictorial riddles and puzzles that were able to suggest, but also conceal, the underlying significance of an object in a painting. To anyone who did not understand the key to interpretation of the object, it would simply appear a realistic object.

Bodegónes (still-lifes) were accepted as a worthy genre in the Sevillian art world from the end of the sixteenth century forward. They often conceal an allegorical meaning: fruits symbolized the four senses of smell, sight, taste, and touch, but they could also hint at vices and virtues. The taste for painting fruit and flowers had been inherited from the Andalusian Moors, whose poets used to celebrate gardens and orchards, comparing the beauty of the flowers and fruits to that of women and children. *Bodegónes* could also include a moral teaching through the addition of hour-glasses, skulls, and other objects that alluded to the inexorable passing of time and thus remind the observer of the vanity and transience of earthly life.

However, at that time *bodegónes* were a genre on the bottom rung of the ladder of importance. In his *Arte de la pintura* Pacheco states, "And so? Still-lifes are not worthy of respect? Yes indeed, if they are painted in the manner of my son-in-law, who distinguishes himself in this field more than any other, and they deserve the very highest consideration; since, with these beginnings and portraits, of which we will speak later, he achieves a true imitation of nature, encouraging with his powerful example the spirits of many."

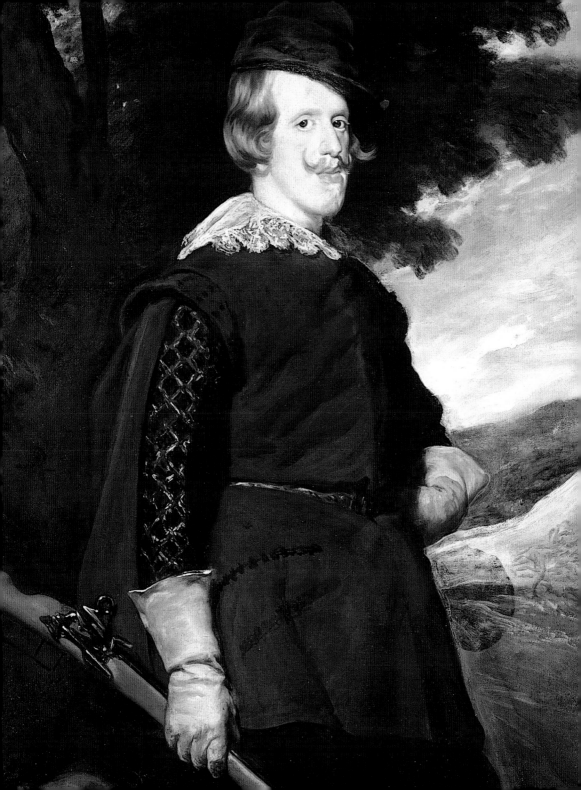

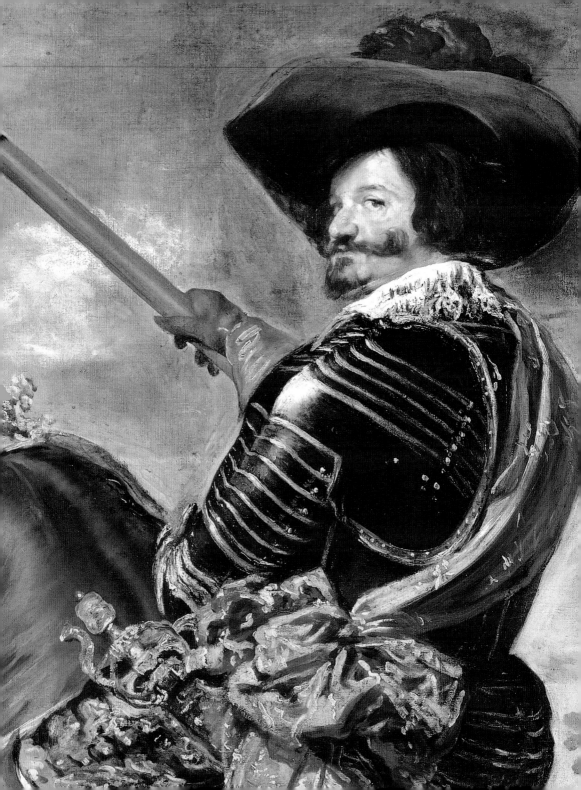

In his early paintings Velázquez tended to group elements typical of still-lifes, such as bread, fruits, wine jugs, and vegetables, with other inanimate objects, knick-knacks made of majolica or clay, and metal or crystal containers, placing them all on a table or shelf. These everyday, common objects were not the main element of the paintings, as was the case with painters who specialized in still-lifes, but he used them to tell stories, some profane, others religious, in which the characters (cooks, servants, or young men cheerfully eating or drinking) were deliberately taken from the lowest social levels.

His precocity is evident in the high quality of the works he painted at the age of seventeen or eighteen. Rather than a diligent pupil, his paintings suggest that a child prodigy was at work, a young man open to, and interested in, innovation. His subsequent departure for the royal court not only opened an important chapter in his artistic development but led to the enrichment of the history of art.

In 1621 King Philip III of Spain died in Madrid. His successor, the young Philip IV, appointed as his prime minister the count-duke Gaspar Guzmán de Olivares, a Sevillian who had been educated in Rome and whose admission to the Spanish court opened up great opportunities for all Sevillian artists.

On the advice of his former master Pacheco, Velázquez made his first trip to Madrid in 1622, filled with hope, at the age of twenty-three. His goal was to advance in his profession and to try to enter the service of the king of Spain. At that time the Madrid court was dominated by Olivares who, as mentioned, favored the Sevillian world from which he had come and from where he picked his most important collaborators. Despite this propitious milieu, it was not possible for Velázquez to portray the king. Nonetheless, the painter did not return from the capital empty-handed, since he succeeded in painting the portrait of one of the most unusual figures at court: Philip IV's chaplain of honor, one of the men most harshly criticized by much of the

intelligentsia in Madrid. This man was the poet Luis de Góngora y Argote (1622, Museum of Fine Arts, Boston). Pacheco tells us that the portrait was painted at his own suggestion, as the old master wished to include it in the book he was preparing of portraits of illustrious men. In spite of this, the choice of Góngora must have delighted Velázquez, as he knew that the old poet, then sixty-two years old, was at the height of his fame and one of the most prominent men of the time due to the intellectuality of his work and his decidedly disagreeable character. If the choice of subject was good, the quality of the portrait was even better, and the painting was admired and applauded at court. It may have been this circumstance that prompted the immediate return of Velázquez to Madrid in 1623 following Philip IV's request to have his own portrait painted by the artist. The king was so pleased with the result that shortly afterwards he appointed Velázquez his 'chamber painter,' which meant that the Sevillian moved his whole family to Madrid, lived in the royal palace like a court dignitary, and painted in his own workshop at Philip's service.

The presence of an official painter in the royal palace is a reminder of how important the possession of works of art must have been as a symbol of political power. The many portraits of the royal family and celebratory paintings of historic events were often used as diplomatic tools. Even in the views of Spanish and foreign cities one can discern a hidden political intent: to remind the ruler of his possessions, and the visitor of the extent of the territories belonging to the nation he was dealing with.

Velázquez's skill in tackling these themes was outstanding and thus attracted the envy of his colleagues, who claimed that "all of his mastery comes down to knowing how to paint a head." To demonstrate the extent of his artistic inventiveness to the envious, he was obliged to produce several large works that, sadly, were lost in the fire in the Alcázar in 1734.

Living in the court, Velázquez was able to leave behind him the social and economic

limitations that had restricted and obstructed him in Seville. A successful period began that would lead to him receiving important posts in the life of the palace, culminating in the *Orden de Santiago*, an honor reserved for the highest levels of the nobility.

As painter to the king, Velázquez did not have to deal with any client other than the king, and his works for private individuals became increasingly rare. When he first arrived in Madrid he accepted commissions to paint several portraits which were remunerated in the same way as a standard commercial transaction, but he later became exclusively the king's artist and did away with any "low and servile" commercial activity, which he considered a hindrance to his social rise.

It is significant that following his arrival in Madrid he almost ceased painting religious scenes, which would inevitably have been his principal activity if he had remained in Seville. More important was his daily contact with the extraordinary wealth of the Spanish royal collections, and in particular to the works of Venetian masters. His familiarity with the art of Venice was reflected directly in the development of his personal style, which passed from the dark naturalism of his Sevillian period to the light-filled beauty of his years of maturity, and from earthy tones to limpid blues and silver-greys. Moreover, his privileged position allowed him to indulge in secular themes (such as history or mythology), a rare luxury for artists who worked exclusively for monastic or clerical clients.

Velázquez' service to the Crown brought him a very arduous, though infrequent, duty for a Spanish painter: the chance to travel in Italy, to see and familiarize himself directly with what was happening in the country that continued to be the European center of innovation in all the arts.

Nevertheless, despite being completely immersed in the onerous duties of the palace, preoccupied by his social ascent, and intent on demonstrating that his art was entirely compatible with the nobility and dignity of an intellectual, Velázquez was obliged to spend

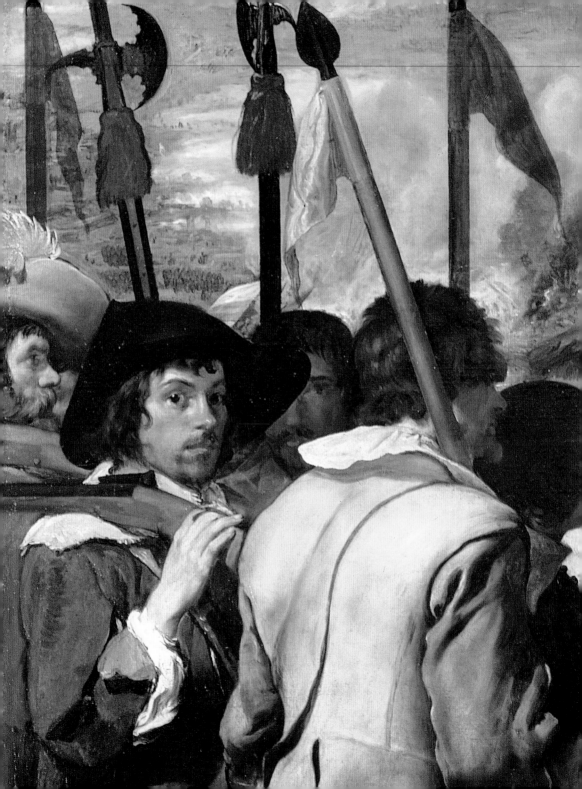

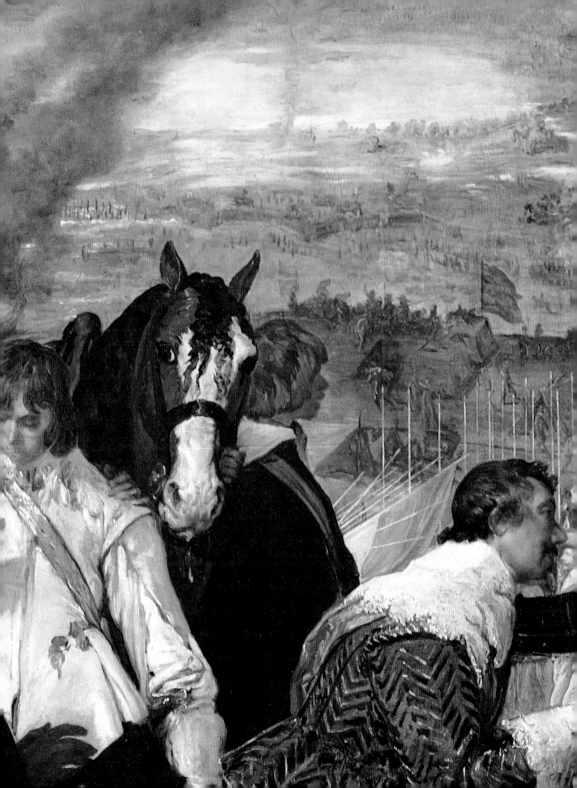

a lot of time on bureaucracy, administration, and questions of etiquette, all of which prevented him from getting on with the business of painting.

In 1628 he met Rubens. The artist from Flanders had already visited Spain in 1603 when he was sent to Valladolid on a diplomatic mission by the Duke of Mantua. On that occasion Rubens had greatly impressed the prime minister, the Duke of Lerma, whom he portrayed on horseback, taking advantage of his pictorial liberty to create a psychological study. The artist had arrived from Mantua bearing paintings and diplomatic messages, and his works of this period betray the influence of El Greco and Italian painting. On his second, longer visit, he remained in Madrid for almost a year, and though he was once again visiting the capital on diplomatic duties, he spent his time studying and copying the art collections of the king, in particular the latest works by Titian. Bearing in mind how much the two had in common artistically, for Velázquez the meeting with Rubens was one of the most important experiences of this period and the one that made him understand more clearly what was necessary for him to achieve artistic maturity.

In June of 1629, after Rubens had left Madrid, probably following conversations with the Flemish master and mulling over what he had been told, Velázquez asked his king for permission to travel to Italy.

On the festival of Saint Laurence, August 10, Velázquez set sail for Italy from Barcelona. Philip IV had given him four hundred silver ducats (equal to two years' salary) and the Count-Duke of Olivares had given him a further two hundred ducats in gold, a medal with the likeness of the king, and various letters of introduction. Thanks to the detailed account left by Pacheco, which was later taken up by Palomino, we know a fair amount about Velázquez's trip. It was for the most part what today we would call a study trip to bring his knowledge of Italian art up to date, with Venice and Rome as his two most important

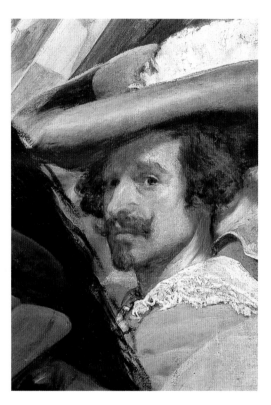

destinations. Officially he introduced himself as the king's *usciere di camera,* but this would not have stilled suspicions about his activities, as artists were often charged with carrying out secret missions.

From Barcelona Velázquez sailed to Genoa with the marquis Ambrogio Spinola (see *The Surrender of Breda*) and from there set out for Milan. From Milan he went to Venice, where he was received by the Spanish ambassador don Cristóbal de Benavides and put up in his house. With some knowledge of Venetian Renaissance painting from the many canvases in Philip's collection, Velázquez was now able to admire the works of Tintoretto and Veronese in the basilica and the Scuola di San Marco. When he was given permission to do so, he visited the Sala del Consiglio and the Scuola di San Luca, though he was always accompanied by the ambassador's servants, as the war of succession in Mantua was creating hostility between Venice and Spain.

We do not know exactly how much time he remained in the *Serenissima Repubblica*

but, according to Pacheco, the less than friendly atmosphere of the city prompted him to move on to Ferrara. There he was taken in by Cardinal Giulio Sacchetti, who assigned Velázquez one of his Spanish servants to show him round the city and take care of his needs. The cardinal was a lover of the arts, a fervent supporter of Neo-Venetian taste, and a patron of young artists like Andrea Sacchi and, in particular, Pietro da Cortona.

Undoubtedly at the suggestion of his host, from Ferrara Velázquez headed for Cento. The reason for a visit to such a small town is not given in any written source, even if most scholars claim that he was motivated by the chance to meet Francesco Barbieri, known as Guercino, who lived there. Guercino was one of Italy's most famous painters, and Velázquez greatly approved of his pure Venetian colors, naturalist approach to the human figure, and heavy, fluid brushstrokes. In fact, the Sevillian used just this technique for one of the most representative paintings of his Italian stay, *Joseph's Bloody Coat Brought to Jacob.*

Passing through Bologna without stopping, from Cento he went to Loreto for religious reasons, and then the last leg of his journey took him to Rome. At that time, the Eternal City was a hive of artistic activity: the naturalism vs classicism debate was in full swing, with the latter represented by the Roman-Bolognese school of Guido Reni and Guercino, supported also by Nicolas Poussin. These were the years in which the most gifted artists in Rome paid renewed attention to Venice and the works of Titian and Veronese, though this interest came to an end a few years later when it flowed into the triumphant baroque style of Pietro da Cortona.

Velázquez arrived in Rome in January 1630 and he remained for a year, aided by Cardinal Francesco Barberini, the nephew of Pope Urban VIII. At first he resided in the Vatican Palaces where, according to Pacheco, "they gave him the keys to some rooms, the main one of which was frescoed, all of the ceiling from the

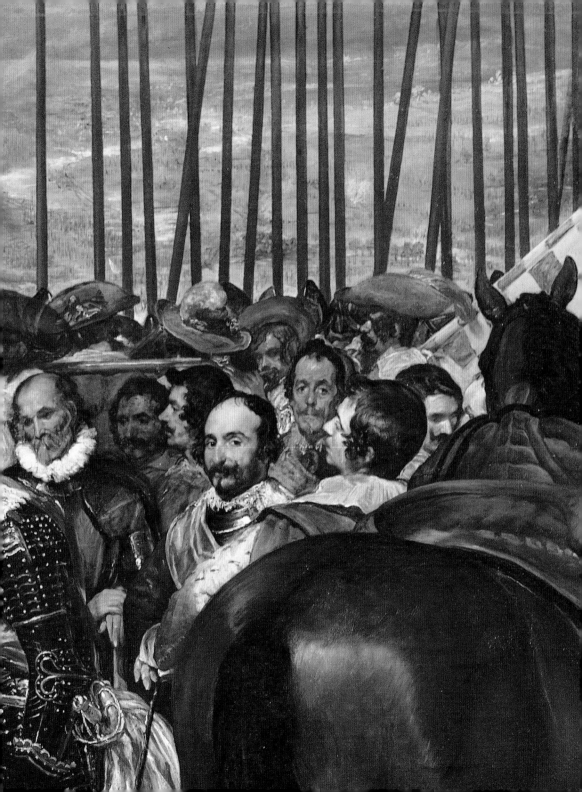

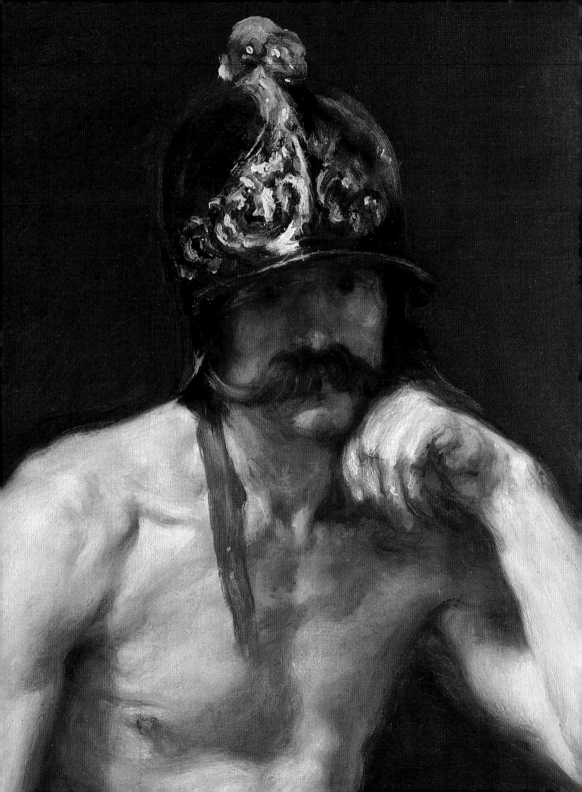

tapestries up, with stories from the Holy Gospel, by Federico Zuccari."

For the entire period that he lived under the patronage of the Barberini family, he studied Raphael's frescoes in the Stanze Vaticane and Michelangelo's in the Sistine and Paoline chapels, reproducing them with pencil and colors. These studies represented a fundamental stage in Velázquez's development as an artist and became apparent in a veiled classicism in his paintings.

Once more relying on Pacheco's account, we learn that the solitude of the Vatican Palaces, and his desire to stay somewhere cooler now that summer was coming, led Velázquez to ask the Grand Duke of Tuscany permission to stay in the Villa Medici at Trinità dei Monti. Here he spent two months in close contact with the Villa's antiquities, copying them faithfully and later using them as iconographic models.

Velázquez felt at ease in Rome: here he developed and fused the precision and balance typical of Bologna with the delicacy of Venetian colorism in his most important paintings of the period, the *Forge of Vulcan* and *Joseph's Coat*. Before returning to Spain he made a visit to Naples, where he had the opportunity to portray Queen Maria of Hungary, who was passing through the city on her way to Vienna with her husband Ferdinand Habsburg.

This first trip to Italy marked the final stage of Velázquez's early development. From this moment on his style and technique changed substantially. The inclusion in his paintings of the models he had studied in Italy, the greater fluency and sureness of his brushstrokes, his renewed sense of color, and even his method of preparing his canvases were to open new horizons for him in his search for beauty. But while he was in Italy his attention was not fully focused on the world of art. His curiosity and his contact with other artists of his generation, like Pietro da Cortona, Andrea Sacchi, and Nicolas Poussin, had introduced him to a new lifestyle. He found a free spirit at large in the academies, literary

circles, and the Roman palazzi decorated with non-religious scenes. In Rome and Venice, paganism, mythology, and Roman and Greek elements were fundamental to understanding religion. He marvelled at the relaxed nature of the two cities' customs, which were very different to the life he was obliged to lead in the dark Alcázar of Philip IV and as a member of a society trammelled by the restrictions of a rigid religious and military tradition.

In December of 1631, at the age of thirty-two, the artist returned to Madrid. His art now excelled that of all his possible rivals at court. He had received the most complete artistic education that a Spanish painter could ever have, his reserved sensitivity had been nourished by useful experiences, and his technical ability had achieved a level of perfection.

He immediately returned to his palace activities and once more received the goodwill and loyalty of Philip IV, who could discern the exceptional gifts of the man who would become his personal painter. During Velázquez's absence, a prince had been born, the Infante Baltasar Carlos, and the king had not wanted any artist to portray him except Velázquez. The first portrait may no longer be extant, but the one of the prince in the company of a dwarf has survived and can now be seen in the Museum of Fine Arts in Boston.

At the Council of Trent in 1545, six of the fifteen members of the commission for sacred images were Spanish, including the Father General of the Jesuits. This heavy proportion influenced the development of sacred art in Spain in the post-Tridentine period, creating a series of forms and methods that were not only stimulated by the vague indications given by the Council, but which came into being naturally as the fruit of a new spirit. The Council's hurriedly composed iconographic prescriptions alone would not have been enough to bring about a new style. In the baroque period, which was generally considered representative of the Counter-Reformation, we do not see the

recommendations of the commission for a plain, straightforward, unembellished art that aimed at restraint. In contrast, the Jesuits exerted an influence on art by occasionally emphasizing the role of non-figurative elements, such as light, or following the tendency to produce clear images of the most common abstract notions, such as the Immaculate Conception. The confraternities and lay congregations throughout Spain popularized preferred the themes of the religious orders, producing an iconography that focused on the worship of Jesus and Mary, the Eucharist, and the patron saints of each city.

Velázquez's learning period had concluded. He returned to palace life and his artistic duties, including the religious themes he had depicted in his early period in Seville. Thus he was bound to alternate sacred art with court portraiture. An echo of classical art derived from Italian painting is discernible in two aspects of his art at this time: the compositions of his paintings, in particular *Christ on the Cross* and *Christ at the Column*, and his use of colors, which was to achieve extraordinary effects in *Saint Anthony Abbot and Saint Paul the Hermit*. He continued to work in the service of the king, producing works of great piety, but never falling into the traps of fanaticism or ostentation. He did not forget the lessons he had learned in his youth but he felt free to introduce symbolic or allusive elements into his works, as he did with great naturalness in the *Temptation of Saint Thomas Aquinas* and again in *Christ at the Column*.

At the instigation of Olivares a new palace was built in Madrid, the Retiro, which was to make an important contribution to Spanish art. For its decoration a large quantity of high-quality paints were ordered from Italy and all the painters in Madrid were involved in the project: painters to the king (Carducho and Cajés), some of their pupils (Castelo and Leonardo) and others like Máino, Pereda, and the Sevillian Zurbarán, who was invited to take part at Velázquez's suggestion.

Surrounded by gardens, the Retiro stood on land that had previously been occupied by an aviary where the count-duke spent his leisure time. During the reign of Philip II a section built by Juan Battista de Toledo had been annexed to it and was referred to as the 'retiro', as it was there that the king would retire during times of mourning or penitence. On receiving the property as a gift from Olivares, Philip IV built an enormous palace there for leisure pursuits which was to become a symbol of the Spanish monarchy. Standing at the other end of Madrid from the Alcázar, it offered everything that the older palace lacked: large open spaces, gardens, kiosks, fountains, residences embellished with works of art by great artists, and a theatre where plays by the best contemporary authors were performed. The Retiro allowed the king to feel freed from the rigid ceremonial life of the court and spend time indulging in the royal family's favorite pastime—hunting. Their enthusiasm for this pursuit had led to the construction of hunting lodges outside Madrid. The royal favorites, even though they were less luxurious, were located at Aranjuez, Zarzuela, Pardo and Valsáin, and it was between these that the court moved when it left the capital.

For the Retiro palace Velázquez painted a series of superb equestrian portraits of Philip III, Philip IV, their respective queens, and the hereditary prince. He also organized the decoration of the walls in the large Hall of Realms, for which he commissioned a series of large battle scenes painted on canvas to glorify the triumphs of the Spanish crown. Velázquez himself contributed with the *Surrender of Breda*, the famous painting also known as *Las Lanzas* (The Lances).

Velázquez also worked on the Torre de la Parada, the small hunting lodge near the Pardo. It was in the Torre that Philip IV had assembled a large number of works by Rubens and his workshop. Some of them dealt with academic themes, such as his painting of Ovid's *Metamorphoses*, while others were lighter in tone but included exceptional still-lifes and hunting scenes.

One of Velázquez's tasks was to portray members of the royal family in hunting dress and with their favorite animals set against the landscape of the Sierra de Guadarrama. The results are surprising: once freed of the obligation to follow the strictures of court etiquette, Velázquez was able to create freer, more insightful psychological portraits of his subjects no longer surrounded by the trappings and symbols of greatness. Such paintings also offered him the challenge of painting landscapes and animals, at which he showed himself fully capable.

Among the thousands of people who made up the court—in addition to the nobility who had come to the palace at the time of Charles V to obtain favors—there were high dignitaries, servants, physicians, pharmacists, confessors, preachers, chaplains, and musicians. The doors of the court were open to all who were able to contribute to its life, even the 'men of pleasure', such as dwarfs, jesters, and simpletons whose physical and mental abnormalities helped to emphasize the beauty

and splendor of the more fortunate. Velázquez, himself a member of the court, masterfully portrayed the 'men of pleasure'. He did not highlight their deformities, but instead attempted to capture their spirits in paint. The result was a series of sincere portraits that occasionally criticized the contradictory world his subjects inhabited. The saddest example is the portrait of the *Jester 'Don Juan de Austria'* who, dressed as a soldier and bearing the name of Charles V's son, the great military commander, became the symbol of the crisis and decline that Spain was experiencing during that period.

After obtaining his painter's license in Seville, Velázquez became a master able to work autonomously. He employed few assistants, most of whom were apprentices. The best known were his servant Juan de Pareja (whom he taught to paint), and Juan Battista Mazo, his official copyist, son-in-law and successor in the coveted position of painter to the king. Mazo is ascribed with various copies of his master's works and it was probably he who completed those canvases that are either known not to have been finished by Velázquez or whose authorship is in doubt. Mazo's contributions were at times preparatory drawings, at others unfinished paintings, but they are all of interest because they shed light on the master's working technique. The procedure Velázquez used to produce a painting was extremely careful and always began with a preparatory drawing. His canvases have very few *pentimenti* (they were rarely retouched) or corrections, a sign that he had a very clear idea of what he wished to achieve before he started.

In the background, political events in Spain continued to affect everyone near power. Uprisings took place in 1640 to demand independence from the Spanish Crown: first for Catalonia, which was unsuccessful despite being supported by the French, then for Portugal, which the country achieved that same year.

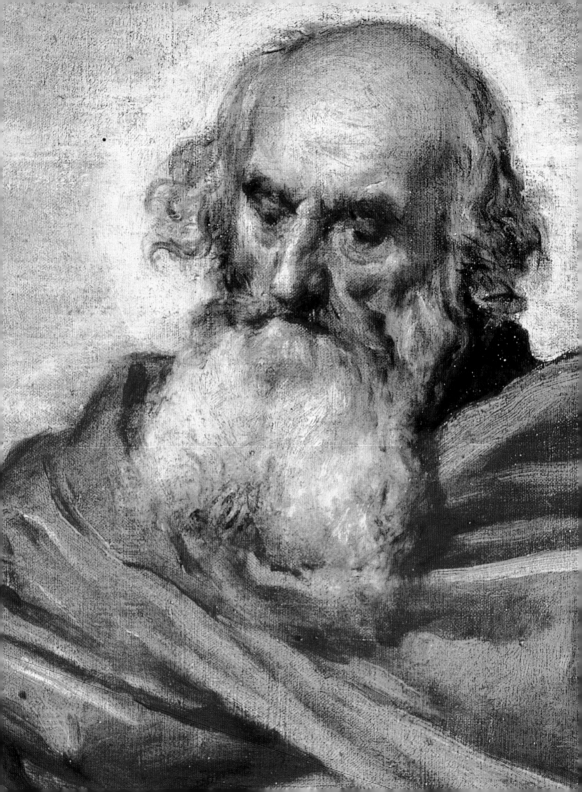

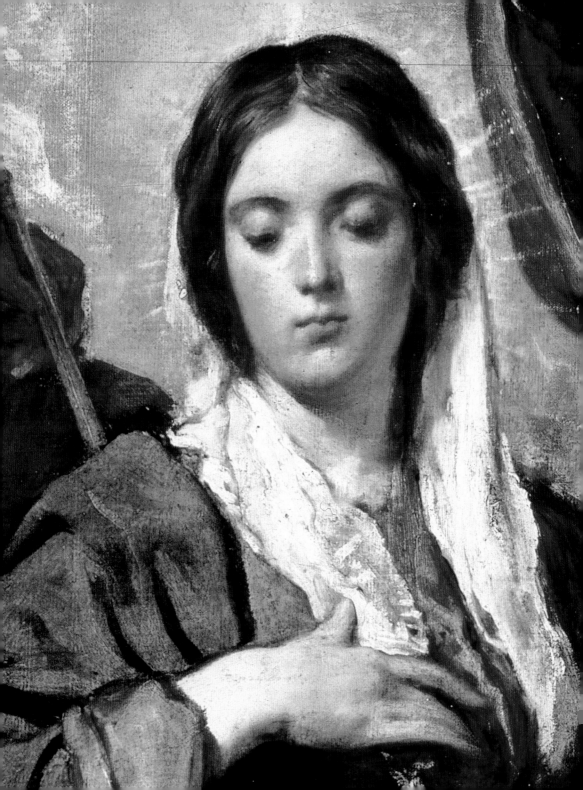

Following the fall of the Count-Duke of Olivares, who was deprived of power in 1643 and confined to Toro in central Spain, the king assumed responsibility for government directly and participated in the military campaign in Aragon. Accompanied by Velázquez, Philip went to Aragon on two occasions and had himself portrayed in June of 1643 in the city of Fraga wearing clothes for excursions in the countryside. During this period Philip suffered a number of family tragedies, with the death of Queen Isabel and the Infante Baltasar Carlos particularly hard blows. We know the degree to which Philip was affected from his correspondence.

In spite of these misfortunes in the royal family, the commissions to Velázquez continued. The need to maintain a certain decorum appropriate to the importance of the empire—which, even if it was wobbling, was still a great European power even compared to the looming France—induced Philip to transform the old Alcázar palace into something a little more in the so-called Italian manner, a technique he had already used in other palaces to symbolize wealth and power. He wished to transform the forbidding Herrerian interior, with its bare vaults, into a modern palace with suites of salons and frescoes.

The task of decorating the palace was given to Velázquez, in particular the octagonal room, which Philip wanted to resemble the Medici Tribuna in the Uffizi palace. Thus Velázquez was appointed *veedor y contador* for the works, in 1647, in other words the inspector and administrator plenipotentiary, a post that caused friction with other palace employees who already resented Velázquez's growing importance in the court hierarchy.

In the words of Palomino, the need to redecorate the Alcázar required a second trip to Italy "to purchase original paintings and ancient statues and to copy some of the most famous which are found in various places in Rome."

The historic and personal circumstances surrounding this trip made it very different

from the previous one. Whereas Velázquez's 1630 journey had been a sort of study trip, the artist was now recognized as one of the greatest masters and his presence in Italy as a close advisor to the king of Spain held a very different personal and artistic significance.

Velázquez had known just how important a trip to Italy was ever since his training period in Seville. His master, Francisco Pacheco, had gathered around himself the poets and men-of-letters of the city to discuss various topics, including Rome, the classical world, and the renaissance of the arts of antiquity. It is probable that this was the setting in which Velázquez's initial desire to visit Italy was nurtured.

In November of 1648 the artist set out for Italy a second time, but on this occasion he carried a special embassy for Pope Innocent X from his king. Velázquez's specific mission was to purchase works of art, original paintings and antique statues, to decorate the Alcázar. He was also responsible for ensuring the walls

of the palace were frescoed, so it was his additional task to accompany Pietro da Cortona to Madrid. At that time the Tuscan painter was considered one of the best specialists in the fresco technique.

Velázquez travelled with don Jaime Manuel de Cárdenas, whose mission it was to meet Philip IV's new bride-to-be, Mariana of Austria, daughter of Emperor Ferdinand and Empress Maria, in the northern city of Trent. Having landed in Genoa, Velázquez traveled to Milan where, rather than participate in the triumphal entry of the queen to the city, he admired paintings and sculpture, including Leonardo's *Last Supper* and "all the paintings and churches that there are in the city".

After a visit to Padua, Velázquez moved on to Venice to see again the masterpieces that had contributed to his own artistic development twenty years before. At this time in Italy there was no painter active that for Velázquez offered anything new, so he returned to the works of the artists of the past and took the opportunity to buy canvases by

Tintoretto and Veronese and some portraits.

Thanks to Philip's explicit mandate, Velázquez had exceptional opportunities to become familiar with the milieu of the Italian nobility. He visited Florence, which he had ignored on his earlier visit, then Modena, where he succeeded in ingratiating himself with the duke. There he had the chance to see Correggio's famous painting in the dome of the cathedral and various works by Parmigianino. Before arriving at the pope's court in Rome, Velázquez made a journey to Naples, where he met up again with the Count of Orñate, Philip IV's viceroy, whose task it was "to assist broadly and profusely" Velázquez in carrying out his mission.

During the first few months of his trip, Velázquez moved around the interior of the Italian peninsula in his guise as a collector and diplomat rather than a painter. He studied the works of the masters of the past so as to choose the best to take back to Spain, and he used his letters of introduction to present himself at various courts, not so that he could

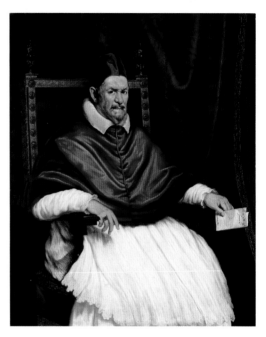

paint the local lords, but to discuss art and purchase masterpieces. His position as the king of Spain's artist gave Velázquez a certain freedom, one that persuaded him to prolong his stay in spite of the king's requests to return to Madrid. He spent two and a half years away from Spain, an entire year of which he passed in Rome, where he finally took up painting again in spring 1650. He only undertook a few portraits, some of which were no more than sketches, but one of them was the painting that immortalized Innocent X Pamphilj.

During this second Italian trip, Velázquez did not enjoy any success as a painter. The only Italian artist who fully understood Velázquez's greatness was a painter from Cremona, Pietro Martire Neri, who reproduced the portrait of Innocent X almost obsessively. The relationship between the two painters was so close that they both signed a portrait of the pope with his nephew.

Despite several attempts by Velázquez, Tuscan painter Pietro da Cortona could not be induced to accept the invitation to Spain, as he was about to enter the service of Innocent X to decorate the family's new palace in Piazza Navona. It was suggested to Velázquez to try two painters from Bologna, Agostino Mitelli and Angelo Michele Colonna, who had both gained reputations for themselves as fresco painters in their own city and in Florence.

A recently discovered episode in Velázquez's stay throws a human light on the artist, whose life had been serene and undisturbed until this time. The reason that he wished to delay his return to Spain, regardless of the repeated requests from his king relayed to Velázquez through the Spanish embassy, was a woman by whom he had a son, Antonio de Silva. The woman in question may have been the painter Flaminia Triva, seen nude in *Venus at Her Mirror*.

The two small landscapes of Villa Medici displayed in the Prado were delicate representations of the city and, on the basis of several indirect references, probably date from this second visit to Rome. During his

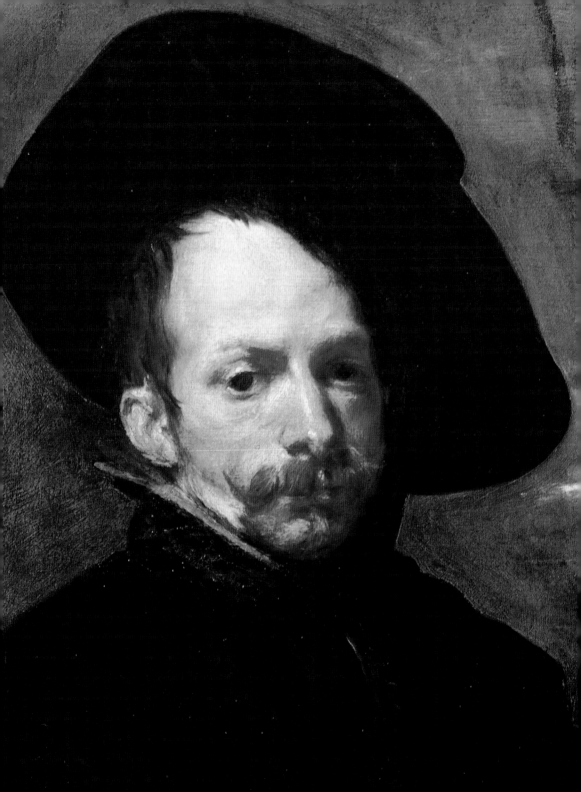

first stay in the city Velázquez had resided for some time in the villa, which was owned by the duke of Tuscany. Now, twenty years later, Velázquez returned and captured, with a lyricism not entirely free of melancholy, the sights that reminded him of his youth. The light, immaterial, almost impressionistic brushwork was an extremely modern technique that was not seen again until the nineteenth century.

The major problems in Philip IV's reign began with the rebellion in Catalonia in the spring of 1640 followed by the Portuguese secession from the Spanish crown in Portugal the same year. These already very difficult events were followed by a conspiracy in Andalusia and revolts in Naples and Sicily that Philip had to appease. The first result was the weakening of the government of the Count-Duke of Olivares, who lost almost his entire support among the Castilian ruling class; the second was the removal of Olivares from his post; and the third was the collapse

of the system of government the count-duke had so carefully created. Philip announced that he would take on the role of government himself but in fact allied himself, with Luis de Haro (Olivares's nephew) and rebuilt a political situation similar to the one created by the count-duke.

The second half of Philip's reign was marked by severe financial problems and a series of heavy bankruptcies. The flow of bullion coming in from the American colonies fell off, and an epidemic of the plague between 1642 and 1652 carried off a tenth of the population. An attempt to balance the country's accounting books by imposing new taxes made the government increasingly unpopular.

For the Torre de la Parada Velázquez was asked to paint a series of mythological or literary figures, like *Mars, Aesop,* and *Menippus.* The most surprising aspect of these portraits was the artist's emphasis on their low-class features and clothing. For the same hunting lodge the king's

father, Philip III, had commissioned mytho-logical scenes from Rubens. Compared to their colleagues in the rest of Europe, Spanish artists painted far fewer scenes from mythology or ancient history. This circumstance is demon-strated by the fact that Velázquez entrusted the decoration of the Torre de la Parada to foreign artists whose knowledge of these subjects was greater.

Spanish literature of the Golden Age was typified by a peculiar satirical tendency towards mythology and Góngara, Lope de Vega, and Cervantes did not hesitate to give the gods the features of common men and women. This irreverent attitude was also mirrored amongst the painters of the time, and Velázquez too stripped his mythological characters of all their greatness. By doing so it is probable that artists, conditioned by the Counter-Reformation, were declaring their lack of involvement with paganism. When given an allegorical slant, myth could also have a moral significance, otherwise it was nothing but a lovely fable that offered only entertainment.

On his return to Madrid in June of 1651, Velázquez had with him the paintings and sculptures he had purchased to decorate Philip's new royal palace, construction of which was well under way. The king was so pleased by what Velázquez had achieved that in June of 1652 he appointed him *Aposentador Mayor de Palacio* (palace marshall). This appointment was proposed by the Royal Council, despite a veto offered by five of its members, and it made Velázquez leapfrog many important figures at court.

Now the artist was among the highest ranked figures of the hierarchy, and his responsibilities at court multiplied. Heavily involved in the running of court life, he was responsible for the travel arrangements of the king and his retinue, the organization of the royal quarters, wardrobe, and tableware, the decorations for ceremonies and festivals, and royal protocol. In short, he was a *mayordomo*. One of his responsibilities in 1656 was the hanging of several canvases in the Escorial, a

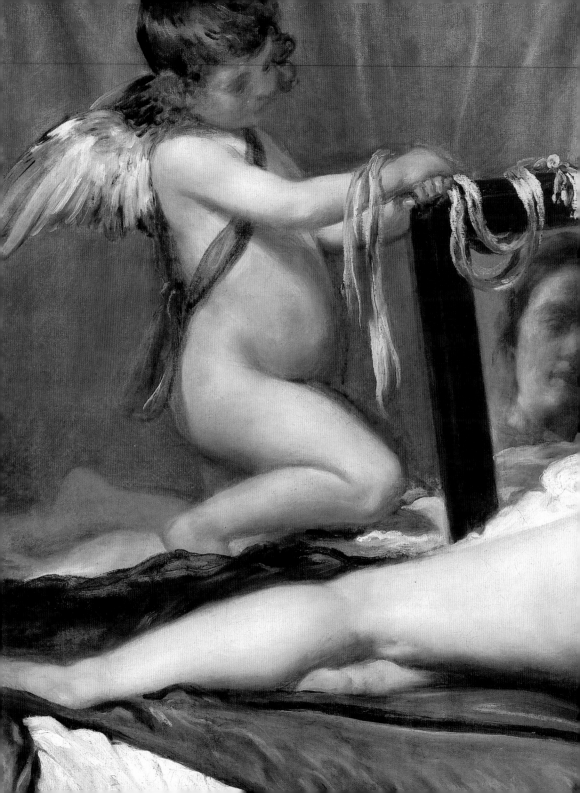

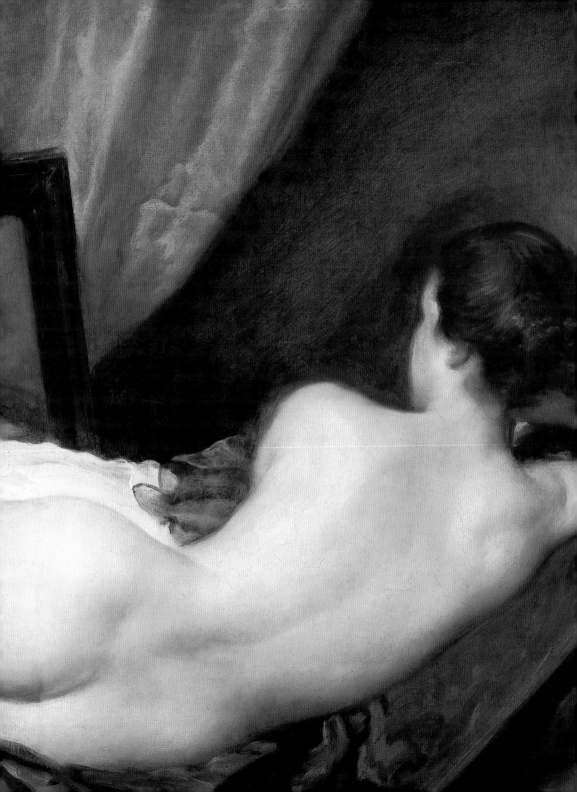

task that revealed Velázquez to be a competent museologist. Although these duties meant he had less and less time for painting, Velázquez still managed to produce such masterpieces as *Las Hilanderas* (The Fable of Arachne) and the four mythological scenes for the rooms of the Alcázar.

Spanish painters of the Golden Age often made use of the painting-within-a-painting technique that allowed them to create a second scene within the principal one; it was also an element that could be loaded with symbolic or allusive meanings dear to the culture of the era. Though it was not exclusive to Spanish painting, it was there that this device achieved its greatest success and subtlety, particularly in Velázquez's works. It had its origins in outdoor views first seen in fifteenth-century indoor decorations. It was in the seventeenth century that Flemish artists took the device one step further to create two appearances within one painting.

The last years of Velázquez's life were marked by a decrease in painting as a result of his pressing court duties, and in order to compensate for this lack of time he made use of assistants in his work. Nonetheless, he was not prevented from painting some very lovely portraits of the royal family in which he perfected his technique, practically dematerializing his brushwork and reducing the appearance of the color to a film. Besides the repeated portraits of the young queen and ageing king, who was increasingly worried about the destiny of his kingdom, the masterpiece of these years was unquestionably the painting once called *The Painting of the Family* but which is today better known as *Las Meninas*. This title refers to the maids-of-honor who surround the Infanta Margarita.

These were the years that he also produced a series of portraits of the young princes and princesses, giving him the opportunity of expressing the delicacy of a child's grace combined with the streak of melancholy that is sometimes seen in children.

Over the years he spent at court, Velázquez had always wanted to be awarded

a title of nobility. In the cultured disputes of the time, he wanted to be able to compete with artists of noble birth so that the intellectual and creative force of his work would be recognized. Having worked for the king for so long, he was no longer satisfied with high office nor the respect of those with whom, thanks to his art, he was surrounded. Finally, after a long lawsuit, he was accepted as a member of the knightly Order of Santiago, something that was traditionally closed to painters, their families and anyone who performed manual work. After establishing that he had, at least in part, noble origins, and received a dispensation from the pope for what was still lacking, on June 12, 1658 Velázquez was granted knighthood. Two years later, having returned to Madrid from Pheasant Island where he had organized a ceremony for the betrothal of the Infanta to her future husband, Velázquez fell ill and died shortly after, on August 6, 1660. The pomp of his funeral, which was held the next day, was a demonstration of the high social level he

had achieved. Seven days after his own death, his unobtrusive wife Juana, Pacheco's daughter, also died. The inventory of his goods taken during the next few days, which included luxuries infrequently found in the Spain of his time and exceptional for a painter, gives us valuable information on the undoubtedly high quality of his life. His library was well stocked with books on architecture, mathematics, astronomy, astrology, ancient history, and philosophy, and many works of Spanish, Italian, and Latin poetry. What is equally surprising is the lack of religious books in his possession.

A posthumous accusation made by his enemies of defrauding the crown while performing his court duties put his goods under confiscation, but a later investigation proved him innocent. His biographer Palomino refers to this accusation as follows: "Even after his death he was persecuted by envy to the point that, when a few trouble-makers attempted to lose him the good opinion of his Majesty with slanderous

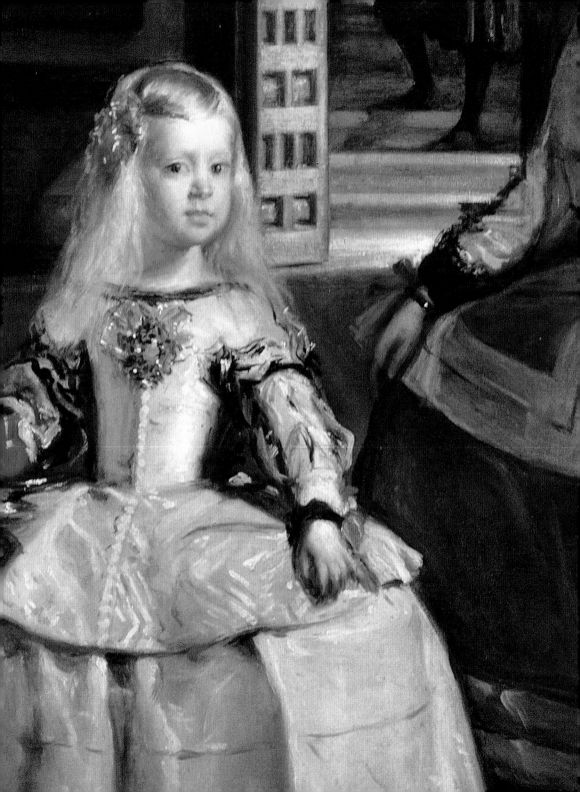

accusations, it was necessary for don Gaspar de Fuensalida, as his friend, testamentary and as Chancellor, to exonerate him in a special audience with His Majesty, assuring the king of Velázquez's faithfulness and loyalty and his rectitude in every act. 'I certainly believe in what you tell me of Velázquez, as he was very capable', replied His Majesty."

The painter's modernity was only recognized in the nineteenth century when painting moved increasingly away from literary themes and back towards figurative art. Édouard Manet called Velázquez *le peintre des peintres* (the painter of painters) and declared that the *Jester Pablo de Valladolid* was "perhaps the most amazing work of painting ever produced." The impressionists recognized Velázquez as the precursor of pure vision and celebrated him as the pioneer of modernity.

During the twentieth century, when the greatness of the artist was universally acknowledged for the first time, the opinions on his work, though sometimes contradictory, fell basically into three categories: the first includes those that base their assessment of the painter on his plasticism (the ability to give the impression of three dimensions on a two-dimensional surface), the quality of his rendition of materials and surfaces, and his pictorial skills (most importantly the excellence of his brushwork, arrangement of the colors on the canvas, and the freedom he demonstrated in the procedure undertaken to achieve apparently concise results). The second approach to Velázquez's painting, and the one that represents most critics' opinions, relates to the meanings embeddedin his works, their iconography and iconology. This trend, which seems to have become prevalent in more recent historiography, highlights Velázquez's profound ability to capture reality in all its nuances, at least as a secondary element. This line of argument, which has been extant since the studies on Velázquez made by Carl Justi, starts from consideration of the importance of the images, and the presence of pictorial

illusion as a principal element, without the need to look outside the frame to understand the picture's fundamental value. The third category has its origin in Michel Foucault's famous chapter on *Las Meninas* in his book *Les mots et les choses* (The Order of Things); it tackles each work almost independently of the existence of the painter himself, and concentrates on the sensations experienced by the observer; in other words, on the visual impact that Velázquez's canvases undoubtedly had on his contemporaries and which continue to exert their fascination on us today. Foucault's observations on *Las Meninas* state: "The painter observes, his face slightly turned and his head cocked towards his shoulder. He gazes at an invisible point, one that we, the observers, cannot easily identify because it is actually we who are that point: our bodies, our faces, our eyes. Thus the sight that he is watching is twice invisible: first, because it is not represented in the space of the painting, and second, because it is situated in the blind spot, in the bare panel in which our gaze is

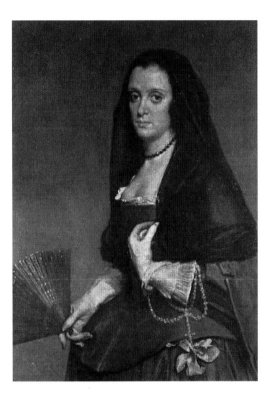

stolen from us even as we look at it. The other single-hued rectangle that fills the entire left part of the real painting, which represents the back of the canvas painted, provides a superficial form of the invisibility of what it is that the artist is looking at: this space in which we are, what we are. From the eyes of the painter to what he is gazing at there exists a direct line that we—ourselves, whom we are looking at—cannot avoid: it passes through the real painting and is united in front of his surface in that place from which we see the painter who is observing us; this pointillism reaches us irremissibly and ties us to the representation of the painting."

The participation of the observer in the canvas is the most typical characteristic of Spanish baroque, the baroque that makes the illusion of truth and appearance its *raison d'être* in an attempt to confuse the observer, to make us doubt what we see and question sensorial reality itself. In his consideration that this aspect is the fundamental one in the picture, or rather by looking at all of *Las Meninas* from this viewpoint, Foucault argues that Velázquez's painting in general has a substantial dimension of reality and judges his art by the impact it made on its contemporaries, which to a large extent it still has today.

The only attention paid to Velázquez's art in the generation that came after him related to his use of color or the copying of some of his models, for example, that of his official portraits. Indeed, it was only at the end of the eighteenth century that the Sevillian's greatness was really discovered, through the engravings of his works by Francisco Goya and Antonio Salvador Carmona.

What is most striking about this master, who had no serious rivals in Spain, is foremost the modernity of his works. Goya analyzed them carefully, translated them into engravings, and used them as models in producing his own official portrait of the family of Charles IV (Prado, Madrid). After making an engraving of *Las Meninas* in 1778, for a royal portrait he depicted the family on

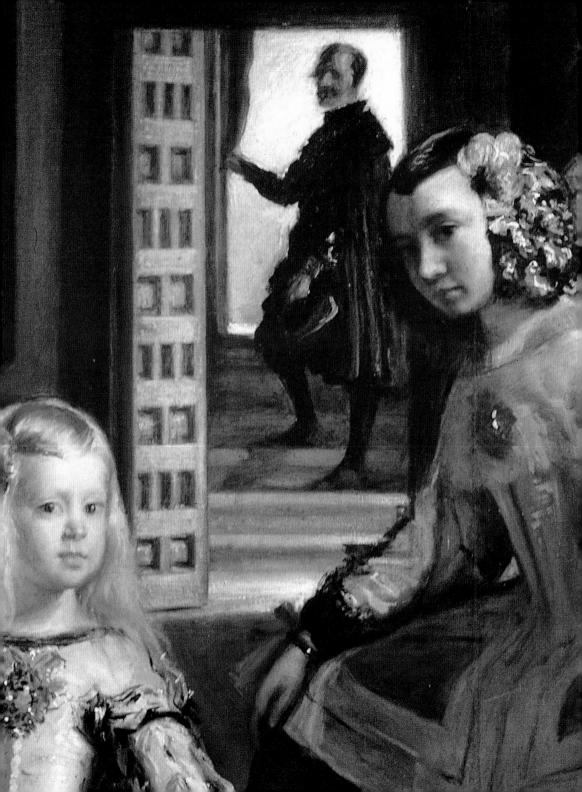

a visit to his studio and inserted himself in the background painting the scene. He also endowed the children with the same astuteness that Velázquez had glimpsed in the Infanta Margarita.

Las Meninas also struck Pablo Picasso strongly, who claimed he had felt attracted to it since he was a boy. He began to practice by copying Velázquez's paintings in the Prado in 1897, and in 1957 he produced roughly sixty canvases inspired by *Las Meninas* in particular, in an attempt to investigate fully the relationship between light, space, and color.

In the 1960s the Spanish art group called Equipo Crónica drew on Velázquez's oeuvre to criticize the politics of the era. They took figures painted by Velázquez, for example the Count-Duke of Olivares, to represent the Spain of Franco as authoritarian and repressive.

After his two trips to Italy, Velázquez's palette of colors became increasingly paler and the scenes in all his works were imbued with a luminous atmosphere. These effects of light and color provided not just depth but a dimension ever closer to the life of his figures and objects, whether close or distant, that at times presuppose a series of variable focal points within a single canvas. Two centuries later, having understood that a painting could portray life without violating the principles of realism, Monet and Renoir applied the same approach in their own paintings.

Exceptional ability was required to achieve success using a pictorial style that attempted to be both convincing and fascinating. It seems that Velázquez's power of perception never ceased to develop; he became ever more ambitious, and his art was increasingly able to express this perception. It is surprising that following his appointment as palace marshall he still had the time to paint. It is thought that, though he found the time, he was obliged to paint very quickly and was unable to go over his canvases again, so that often they appear unfinished. However, this was not the case for those paintings that were commissioned from him: the king was

understanding of Velázquez's requirements and indulged this exceptional artist of whom he was very fond.

Still more surprising is the fact that, when painting very large canvases, the artist did not outline any initial design, and indeed did not make use of sketches or even preliminary studies. Uniting absolute belief in the fundamental importance of color with an extraordinary talent for composition, Velázquez could boast an exceptional technique. However despite the success of some of his assistants and pupils, his pictorial form did not generate a school. Nevertheless, his style of extended brushstrokes, powerful visual impact, gradation of chromatic planes, and progressive dissolution of forms until he was painting just light and colors anticipated the realist and impressionist painting of the nineteenth century.

The Masterpieces

Three Men at Table

c. 1617
Oil on canvas, 108 × 102 cm
St. Petersburg, The State
Hermitage Museum

The foreground of the painting is filled with great naturalness by a table covered with a creased white linen tablecloth on which stand two pomegranates and a loaf of bread. Sitting around the table are an elderly man on the left, a young man on the right, and in the background a boy who pours wine from a glass carafe in a cheerful, carefree manner. Hanging at the back of the room are what appears to be a white collar made of fine cloth, a leather bag and, on the right, a sword, made more evident by the shadow it casts on the wall and its metallic glint.

The hand gesture of the young man sitting on the right, which is without doubt directed at the observer, probably expresses *collateraliter monstro*, literally "I am indicating the person at my side," according to our knowledge of the gestures of the period, which are based on the gestures and behavior of actors. He is indicating to us the happily laughing boy at his side who holds up the carafe of wine or must.

Velázquez may have intended the painting as a moralizing scene. The depiction of an old man with two young men was a tradition that dated back to the Renaissance. Notable examples are a famous work by Raphael in Rome, and in sixteenth-century Venetian painting by Giorgione and Titian, all of which refer to the three ages of man.

On this occasion Velázquez may be interpreting a classically derived theme in a naturalistic sense, particularly if we consider the literary and humanistic circles that he, and most certainly his master Pacheco, frequented.

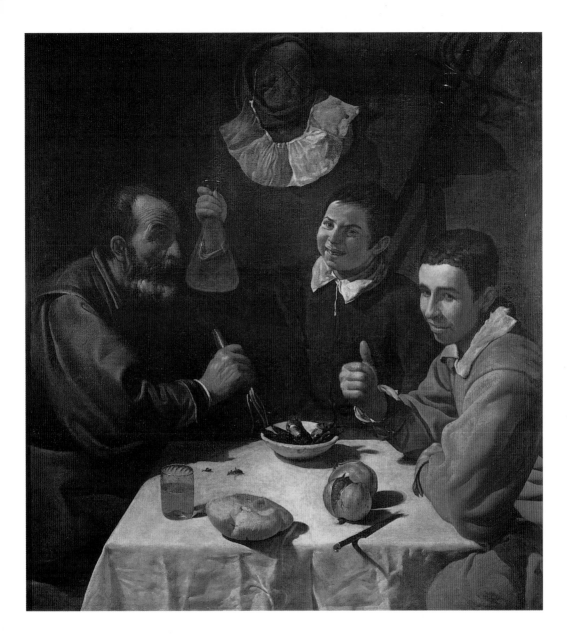

Old Woman Frying Eggs

c. 1618
Oil on canvas,
100.5 × 119.59 cm
Edinburgh, National Gallery
of Scotland

The painting is dated to 1618 and was executed in Seville before Velázquez went to Madrid in 1622.

The artist began his painting career with the _bodegones_ genre that was so appreciated by the people of Seville. This technique differed from simple still-lifes in that it placed simple, humble figures next to objects and foods in the setting of a tavern. The everyday nature of these themes usually hid allegorical meanings. Some contemporaries judged this painting negatively, to whom Pacheco replied, "Still-lifes are not worthy of respect? Yes indeed, if they are painted in the manner of my son-in-law, who distinguishes himself in this field more than any other, and they deserve the very highest consideration; since, with these beginnings and portraits he achieves a true imitation of nature."

The painting shows an old woman seated in front of a clay vessel cooking eggs. She holds a wooden spoon in her right hand and with her left prepares to crack an egg on the edge of the saucepan. The woman's face, beneath the masterfully painted veil, is solemn and pensive; equally serious is the boy who faces the observer with a melon in one hand and a flask of wine in the other. The two figures are as still as the objects that surround them, and they gaze in different directions. The scene is balanced and perfect: the darkness of the left side of the painting is balanced by the brightness of the right, created by the jug, the whiteness of the plate, and the egg in the woman's left hand.

The contrast between youth and old age symbolizes the transience of earthly life, and the egg in the woman's hand is the emblem of regeneration. The elements in the scene are very realistically painted: from the eggs, the mortar, the shadow of the knife in the bowl, and the two carafes, to the onion.

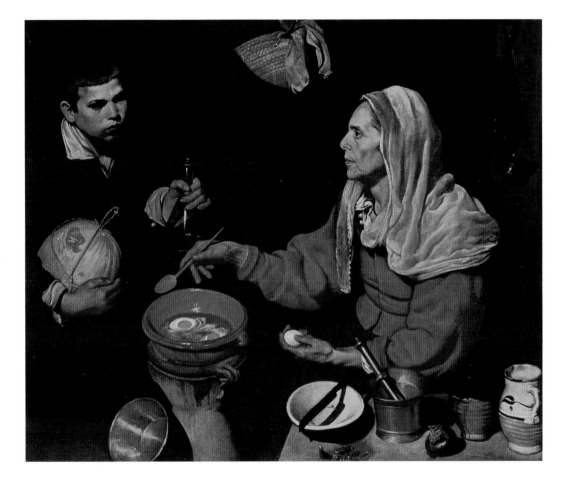

1619
Oil on canvas, 203 × 125 cm
Madrid, Museo Nacional
del Prado
Dated 1619 on the stone
by the Virgin's foot

This painting, which may have been made for the Jesuit novitiate of San Luis in Seville, is an example of the need to update the scene on the basis of the *Spiritual Exercises* of Saint Ignatius Loyola, whose recommendations were to consider spirituality an element of everyday life, and therefore perceptible through our senses.

The stone at the base of the group of the Virgin and Child is inscribed with the first date to be added by Velázquez to one of his paintings: 1619, the year following his marriage to Pacheco's daughter Juana, and the year his first daughter, Francisca, was baptized. Because, like Caravaggio, Velázquez wanted to make use of members of his family as models, we may hypothesize that this Epiphany is a family portrait: the baby Jesus may be his daughter, the Virgin his wife, and, with regard to the three Magi, Melchior may be Pacheco, Gaspar Velázquez himself, and Balthazar a servant.

Velázquez's scene shows none of the splendor with which the three kings are typically portrayed. Dressed in simple cloaks and frocks, the only touches of magnificence are Balthazar's embroidered collar and the gold cups that contain their gifts (gold, incense, and myrrh). The holy figures are very realistically portrayed: the Virgin, holding the Child in her strong, stocky hands, could be any girl from Seville; the Child himself is very striking, his bound figure contrasting with the alert, comical expression on his face. At that time, and almost up until the last century, it was customary to bind newborn babies so that not even their legs were left uncovered. A bright source of light from the top left corner illuminates the dark, subdued tones. The detail of the dawn landscape in the background and the suggestion of the shrub in the foreground are hints of the quality of the future landscape artist, who contented himself in this picture with experiments in *tenebrismo*.

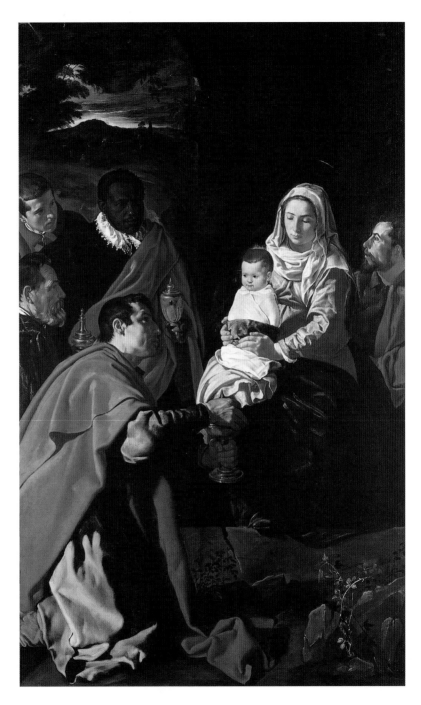

Kitchen Scene with Christ in the House of Martha and Mary

c. 1620

Oil on canvas, 60 × 103.5 cm
London, The Trustees
of The National Gallery

This is one of the most interesting and fascinating pictures from Velázquez's Sevillian period. It shows a young woman in the kitchen as she grinds garlic in a mortar. On the table are two eggs and a spoon in a plate, four fish in a dish, and a small amphora that probably contains oil: this still-life is illuminated by the light that also falls on the faces of the women.

On the left of the canvas, behind the young woman, is an old woman wearing a cap. She indicates a scene taking place on the other side of the painting visible either through a window or as the reflection in a mirror. The scene is of a bearded, long-haired man dressed in a tunic and seated in an armchair who stands out against a dark door behind him. His pose, suggested by the gesture of his left hand, is one of a teacher, and he faces a woman seated on the ground at his feet who listens to him devotedly. Behind the woman on the ground stands an old woman wearing a cap like the one in the foreground and raising her arms slightly in the air as though she wished to interrupt the master's lesson.

The scene is of Mary listening attentively to the words of Christ as Martha works in the kitchen. The old lady who appears twice (behind Mary and also behind Martha) might be a neighbor who incites the working Martha against her sister who has remained to hear the words of Christ.

Velázquez introduces different levels of reality in the picture —paintings within the painting—which refer and relate to one another regardless of the picture's overall interpretation. This was an artistic concept that Velázquez was to take much further in his late masterpiece *Las Meninas*.

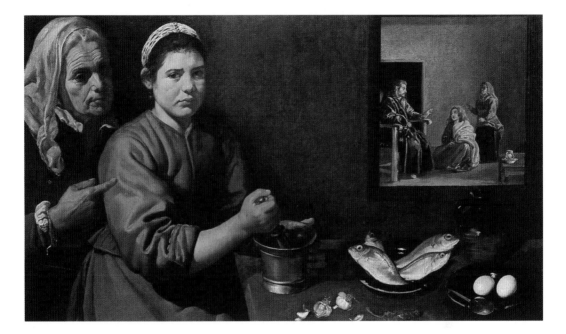

Portrait of a Man with a Goatee
(Francisco Pacheco?)

1620
Oil on canvas, 40 × 36 cm
Madrid, Museo Nacional
del Prado

In this canvas Velázquez portrays his master and father-in-law dressed in black with a pleated ruff. Francisco Pacheco was baptized Sanlúcar de Barrameda in 1564. When still young he went to Seville, where we hear of him as early as 1583, protected by his uncle, a university graduate and academic. A pupil of Luís Fernández, he knew Spain well, though he never left the country. A court painter and renowned artist, he was an inspector for the Inquisition on the subject of religious paintings. He made interesting annotations in his *Libro de Retratos* (1599) on the most distinguished figures in the world of literature and art, and on the Sevillian clergy, in particular on the Jesuits, from whom he accepted advice on the rules of iconography which he included in his treatise *Arte de la pintura* ("The Art of Painting"). He completed the treatise in January of 1638 and it was published posthumously.

Considered one of the masters of the generation that passed from mannerism to naturalism, Pacheco was famous as a religious painter. His works are of a certain quality, but invested by academic coldness. Envious of his son-in-law's talent, his writings include an appreciation of Velázquez, whom he held up as a model for painters. He died in Seville in 1644.

Velázquez portrayed Pacheco with an alert expression, almost ready to undertake a dialogue. In his pleated ruff, an item of clothing later prohibited by Philip IV's austerity program, Pacheco is shown with an extraordinary capacity for observation, and his personal vigor seems to be represented by the disorderly arrangement of the pleats.

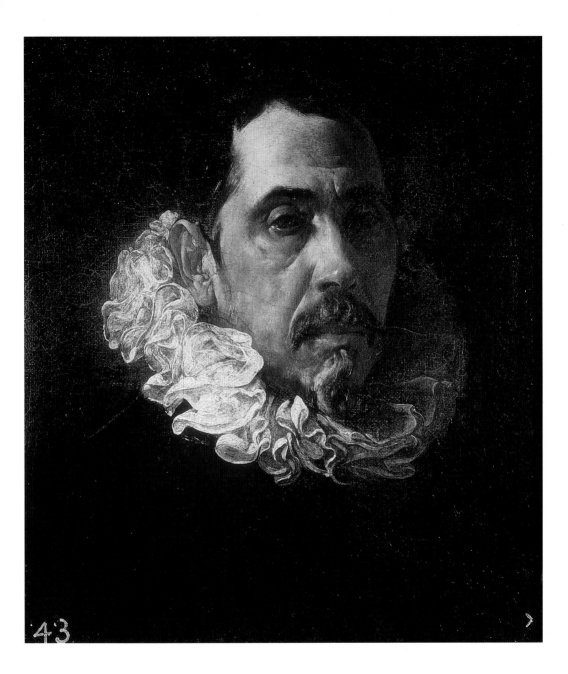

43

1620
Oil on canvas, 105 × 80 cm
London, Wellington Museum
(Apsley House), The Board
of Trustees of The Victoria
and Albert Museum

The painting shows an old man wearing simple, ragged clothes as he offers a glass of water to a young boy. The transparency of the liquid it holds allows us to see a fig added to perfume the water of *virtù salutifera*. The boy with his head slightly inclined approaches respectfully to receive the glass. In the shadows between the heads of the two figures we make out the head of a young man as he drinks eagerly from a clay mug. An interpretation for this painting might be the three ages of man, in particular that of the mature man who achieves understanding.

The arm of the old man that rests on the amphora emerges from the ripped sleeve of the dark tunic and invades the observer's space. This well-known pictorial device seems to herald the still-lifes of Cézanne and Juan Gris. An imaginary spiral of light seems to radiate from the amphora in the foreground, pass to the smaller vase that stands on a bench or a table, then come to rest in the three faces, ending with that of the elderly water-seller.

To the eyes of contemporaries this solemn scene also had a burlesque aspect: in one of the picaresque novels that were so common at the time—and an expression of Spanish society on par with the works of Miguel Cervantes—there was a water-seller from Seville similar to Velázquez's character.

The composition is imbued with a degree of stillness similar to that seen in the *Old Woman Frying Eggs*, and the artist's total control over the design and volumes is evident. Two copies of the painting exist, one at the Walters Art Museum in Baltimore and the other at the Uffizi in Florence.

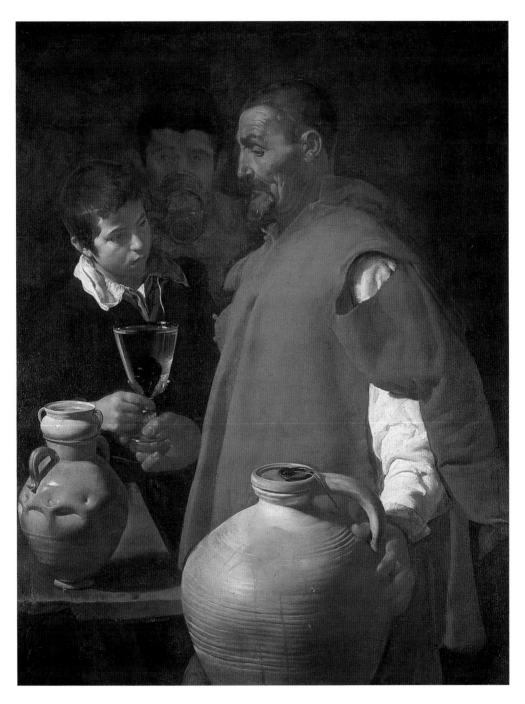

A Young Man
(Self-Portrait?)

1623

Oil on canvas, 56 × 39 cm
Madrid, Museo Nacional
del Prado

The painting is of a young man wearing a black jacket and a small white collar over which his dark-skinned face emerges from the surrounding darkness. His hair is black and thick, as are his eyebrows and moustache. His dark eyes gaze intently and serenely, he has an aquiline nose and strong chin, and his fleshy lips are well outlined. Emphasized by the grey background, everything about him suggests honorableness, tranquillity, and naturalness.

Although this painting has always been recognized as being one of Velázquez' works, there have been differing opinions on its authenticity; for example, Beruete considered it a copy. These considerations influenced the Prado's catalogue which, in its 1903 edition, described the painting as only attributed to Velázquez, though earlier editions had considered it definitively by his hand. Pantorba believes that it was painted in Seville in 1622–1623, and the museum catalogue dates it to 1623.

Since 1933 the catalogues have considered the work authentic and, according to Allende-Salazar, probably a self-portrait. He claims that "the direction of the gaze, the resemblance to the model in *Saint John on the Island of Patmos* lead one to hypothesize that it is a self-portrait." Jacinto Octavio Picón also supports this premise due to the fixedness of the man's gaze: "The expression of his eyes is both avid and penetrating, fleeting and searching, just like the look of someone who is looking rapidly at what he is painting. Having made this observation, it is difficult to reject the idea that these eyes are looking into a mirror."

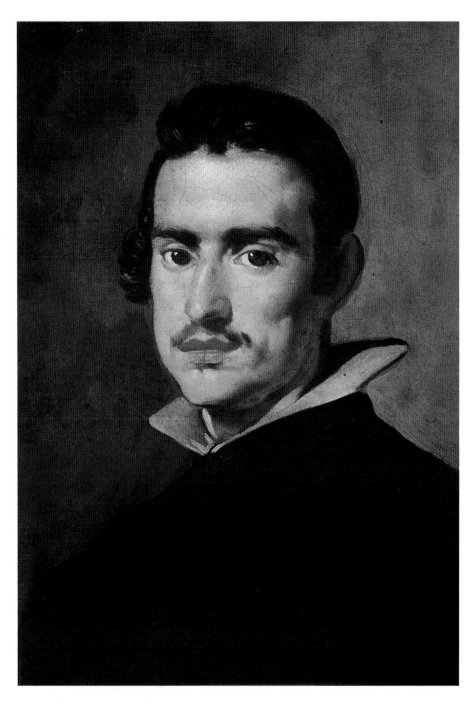

Saint Idelfonso Receiving the Chasuble from the Virgin

1623
Oil on canvas, 166 × 120 cm
Seville, Museo de Bellas Artes

The influence of El Greco (1541–1614) is apparent in this painting, though Velázquez developed it further with remarkable self-confidence to create an inimitable style of his own. This is marked by a sure touch in his exploration of the depths of his subject, an increasing artistic delicacy, and a fine sense of composition that together reveal the genius beginning to emerge from beneath the guise of an apprentice.

It is thought that the painting dates from 1623, in the interval in Seville between the artist's first and second trip to Madrid. It is probable that Velázquez stopped at Illescas, between Seville and Madrid, and saw the works of El Greco. However, he could also have admired other works by the Cretan artist in Madrid or at El Escorial, and perhaps in Toledo itself.

It is unknown who the client was for this large painting to be used for private devotion, in a style very typical of Toledo. Saint Idelfonso was a very distinguished prelate to whom a highly precious chasuble was presented by the Virgin as a sign of gratitude for his writings and sermons in defence of her virginity.

El Greco's influence on the painting can perhaps be seen in the almost bloodless spirituality of the saint. The strangely triangular composition too is somewhat 'Grecian', created by the fall of the chasuble held by the Virgin over either side of the saint's head, and the burst of light that extracts rays of light from the slightly cold violet of the canvas and is combined with the bluish folds of Mary's mantle.

Pantorba noted that the angels or saints that accompany the Virgin "are simply beautiful Andalusian girls busy, it appears, chatting and therefore completely uninterested in what the Virgin is doing". Mary's head, with downcast eyes and a modest expression, is painted with great self-assurance and touches of brilliant light.

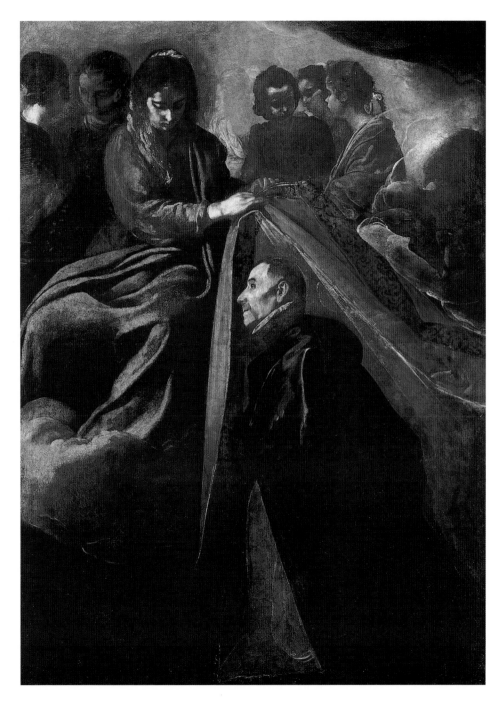

Democritus

1624 (or 1640)
Oil on canvas, 98 × 81 cm
Rouen, Musée des Beaux–Arts

The canvas shows a man wearing a black doublet and red mantle, with an upward-pointing moustache, short bangs, sideburns, and teeth glinting between his thick lips: he smiles at the observer and with his left hand points to a globe standing on a table beside a couple of books. His right hand rests on his hip, creating deep folds in his mantle. It was thought that this slim man with a rough face, mocking expression, black doublet, and white lace collar might be a portrait of Galileo Galilei or Christopher Columbus, but a more recent suggestion put forward by art critics is that it is the Greek philosopher Democritus, laughing at the world, seen here in the form of the globe.

Later alterations to the painting to soften the hands and face show the extent of Velázquez' interest in the work of Rubens at that time. Equal evidence of the influence of the brilliant Flemish master of the baroque was apparent in only a few of the Spanish artist's later paintings, in particular the depiction of Mars, the god of war.

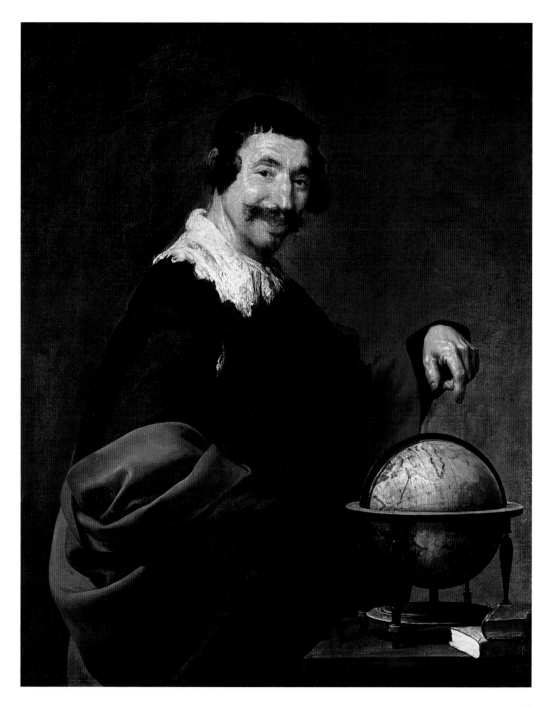

c. 1624
Oil on canvas, 201 × 102 cm
Madrid, Museo Nacional
del Prado

When Velázquez was appointed court painter in Madrid in 1623, one of his first assignments was to portray Philip IV, a task he performed with great success. The Count-Duke of Olivares stated that no one else had painted such a real portrait of the king, meaning that it was exceptionally expressive and at the same time equally realistic.

The portraits of the Spanish Habsburgs, a family Velázquez painted in strict sequence, form the most outstanding series of court portraiture in European art. Despite being unable to express himself as freely as his colleagues working in Paris and Rome, the artist managed to infuse the rigid formulaic approach of the portrait with vitality by employing a new method of visual conception, a method he refined during his first stay in Italy. The main characteristic of this portrait is the vivacity of the king's expression. Velázquez exalts the serene majesty of his face by contrasting it with the many gradations of red in the sash draped over the king's armor.

The Prado catalogue informs us that "it seems that it was painted in September 1628", but Pantorba brings this date forward by two or three years, as Philip does not appear to be more than twenty years of age.

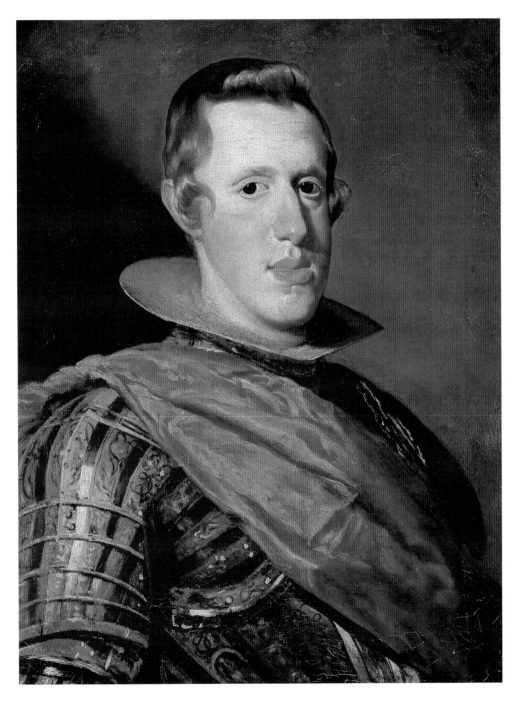

Triumph of Bacchus
(The Topers)

1628–1629
Oil on canvas, 165.5 × 227.5
Madrid, Museo Nacional
del Prado

Bacchus, the god of wine and orgiastic joy, is portrayed half-naked, with the unhealthy flesh of his bust a sickly white, as he places a crown of ivy on the head of a young peasant kneeling in front of him. In this painting Bacchus is portrayed more as though he were acting the role of a god rather than the god himself.

Other figures, some respectful, others amused, watch the parody of a coronation and cluster closely around the god as though he were one of themselves. In the scene the peasants are not relegated—as often happened in the literature and painting of the age—to the roles of fools whose stupidity, by contrast, commended the refinement of an ideal and essential world. On the contrary, Velázquez emphasizes that it is the demanding work of the peasants, on which Spanish social well-being was founded, that is so magnificently rewarded by the god with the joys of wine.

Certain details in the painting refer to the tradition of the *bodegón* and openly demonstrate the extent of Caravaggio's influence in the direct use of motifs (*Bacchus*, Caravaggio, painted in 1598, now in the Uffizi) and through the mediation of the Spanish Caravaggist Jusepe de Ribera.

The face and direct gaze of the man at center toward the observer are reminiscent of the work of Ribera. His laugh changes the solemnity of the ritual into an amusement between *picaros*, and thus suggests that the scene may be a parody of a mythological episode. Slightly hidden by a cloth at Bacchus's feet, the jug and glass bottle (of which we see only the bottom) are a magnificent still-life, almost as though they were a gift offered to the god. Particularly impressive are the reflections that give the objects their volume.

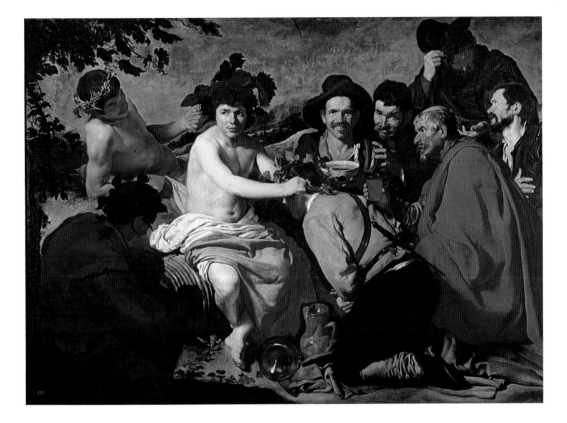

1630
Oil on canvas, 67 × 50 cm
Rome, Musei Capitolini

Direct comparison with other paintings by Velázquez in Rome provides a very useful opportunity to study the authenticity of this painting in the Capitoline Museums. It is a controversial work, and has experienced alternating fortunes in the opinions of experts. Following the exhibitions in 1990 in New York and Madrid, when it was compared in the catalogue with the *Self-Portrait* in Valencia without resolving the issue of its authenticity, it has returned to the attention of art literature once more.

That same year Maurizio Marini claimed once again that it was painted by Velázquez, noting the possibility that it was the self-portrait listed in the post-mortem inventory of the painter and his wife made in 1660. Marini recalled how Velázquez had been made a member of the *Accademia di San Luca* and the *Virtuosi del Pantheon* during his second stay in Rome in 1649–1650. He was elected to this second congregation on February 13, 1650, and the same year was appointed *festarolo* (organizer) of the celebrations held on Saint Joseph's day, the association's patron saint. For the celebrations an exhibition of paintings was mounted in the portico of the Pantheon, and in 1650 Velázquez is thought to have participated by hanging his famous *Portrait of Juan de Pareja*. Marini claims that this painting from the Capitoline gallery shows Velázquez dressed as a member of the *Virtuosi del Pantheon*, with a white collar and black cape.

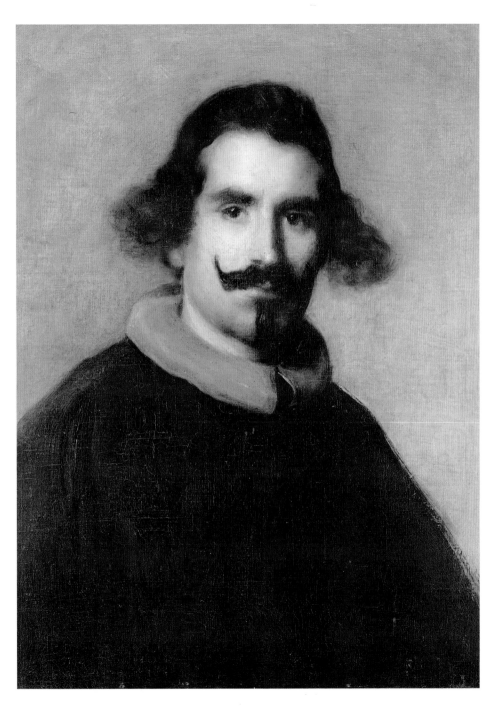

Joseph's Bloody Coat Brought to Jacob

1630
Oil on canvas, 223 × 250 cm
El Escorial (Madrid),
Monasterio de San Lorenzo

This religious scene was painted in 1630 during Velázquez's first stay in Rome. It shows the episode in the Bible when Joseph's brothers, envious of Joseph's preferential treatment by their father, sold him to a caravan of Ishmaelites.

The artist has reduced the number of brothers from ten to five. Two show their elderly father Joseph's coat stained with goat's blood to convince him of the death of his favorite son. Jacob—shown on a small seat on a carpet—stretches his arms forward, his face lined with grief. On the left side of the picture, one of Joseph's brothers, with his back to us, holds his hand to his face, seeming to pretend to cry. Two more, only barely depicted, are seen against a pale background that the artist had presumably intended to continue the lovely landscape seen on the left.

The rendering of the reactions by the participants in the cruel scene has been achieved very effectively. The action takes place in a room with a checkerboard floor, a detail that is often found in the works of Tintoretto and Titian, but unique in Velázquez's corpus. The black-and-white floor is demonstrative of the rules of perspective used in Italy, and the effect of spatial depth is augmented by the staff that has been dropped to the floor.

A lovely, bluish landscape, which testifies to the Sevillian's extraordinary pictorial skills, appears behind the young man who holds his right hand up to his face: the theatrical nature of this gesture is worthy of the academic painting of Bologna and Rome.

The little dog barks at Joseph's deceitful brothers as though it intuited their betrayal. It is a detail that illustrates once more how closely Velázquez observed reality. A symbol of faithfulness in traditional iconography, dogs were to appear in several of the artist's subsequent portraits.

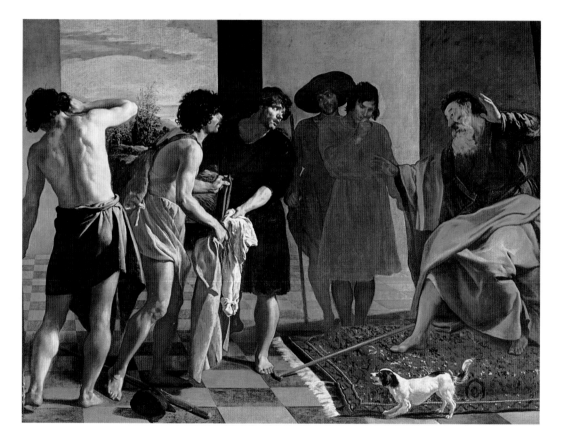

1630
Oil on canvas, 223 × 290 cm
Madrid, Museo Nacional
del Prado

The picture was painted in 1630, during Velázquez' stay in Rome, and seems to have been influenced by the work of Guido Reni and classical statuary. The face of the young god Apollo is especially delicate: blond, adolescent, his mother-of-pearl nudity halfcovered by a yellow mantle, with an aureole around his head, he bathes the half-dark forge in light.

The hot, luminous elements in the scene are a piece of glowing metal, held by Vulcan on the anvil, and the flames in the fireplace. These highlight the bodies of the two smiths who stare amazedly at their visitor and his slightly arrogant pose as they listen to him tell the lame Vulcan that his wife Venus is cuckolding him with Mars, the god of war, for whom the armor in the forge is being made. In the preparatory sketch for the figure of Apollo (private collection, New York), the god's profile is apparently gentler, and his expression more languid and sentimental.

The themes that Velázquez studied during his Sevillian period are here supplemented with new stylistic elements as a result of the artist's encounter with Italian art. The laces of Apollo's sandals, the small white clay vase with bluish reflections above the fireplace, and the blue of the sky seen through the doorway are notes of color that brighten this otherwise somewhat dusty-colored composition.

The smith seen from behind is probably the most academic figure in the scene. Note his resemblance to many models from heroic statuary, even though his thick hair and sideburns contrast with the compactness of his posture and perfect musculature. This small contradiction has its origin in the anti-mythological stance of Spanish culture in the seventeenth century.

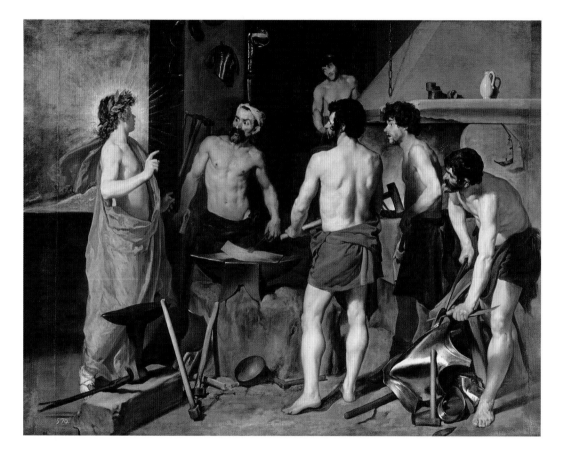

Christ in a Landscape

1631
Oil on canvas, 100 × 57 cm
Madrid, Museo Nacional
del Prado
Signed at bottom left
'D.° VELÁZQUEZ FA. 1631'

Velázquez's signature was discovered on this canvas in 1940. The fact that the artist, who was so unwilling to sign his works, was prepared to authenticate this minor painting raised a certain degree of astonishment.

At the end of the Spanish Civil War (1936–1939) this painting was one of those recovered from the nuns known as the Bernardas Recoletas in the convent of the Sacrament in Madrid. The nuns offered the painting to the Spanish state in return for the reconstruction of the convent, which had been built after Velázquez's time.

Pantorba dedicated a long comment to the painting, including the information that the Servicio de Recuperación Artistica returned it to the nuns in 1940, believing it to be—like the church—from the eighteenth century and by the Madrileña school.

The signature was subsequently discovered by restorers in the Prado and believed to be authentic. This fact unquestionably increased the value of the small painting which, following several negotiations and offers, was purchased by the Spanish state on May 15, 1946, the same date as the rebuilt convent was handed over to the nuns. It then entered the Prado and was placed in the same room as the San Placido *Christ on the Cross*. The first museum catalogue in which it appears was published in 1949, when it was attributed to Velázquez and associated with the painting technique used in *The Forge of Vulcan*.

The painting is very delicate but much less like Velázquez's manner than the San Placido *Christ on the Cross*, particularly with regard to its rather theatrical pathos which, in the expression on the face that gazes towards heaven, brings to mind the heads of Christ painted by Guido Reni.

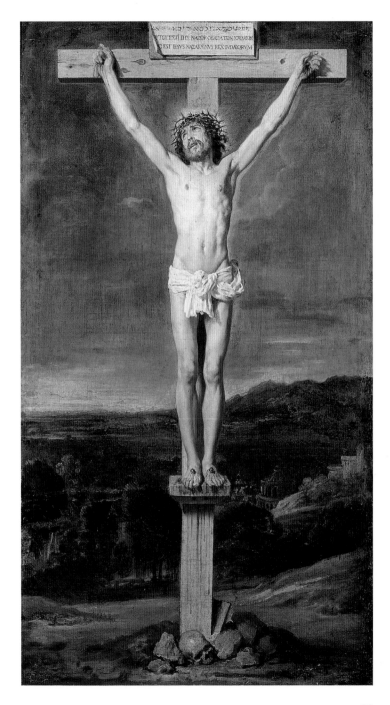

Christ on the Cross

c. 1631
Oil on canvas, 248 × 169 cm
Madrid, Museo Nacional
del Prado

Velázquez's period of early learning was coming to an end. His return to the artistic duties and life in the royal palace in Madrid, following his trip to Italy, meant he was obliged to return to the religious themes he had painted while living in Seville, though alternating them with court portraiture. This painting of Christ on the Cross has a classical aspect that Velázquez derived from Italian art. The canvas is one of a group of religious works (that include *Christ in a Landscape*, *The Temptation of Saint Thomas,* and *Christ at the Column*) that the artist painted in the early 1630s. This is the best known of the four, due not only to its emotional and aesthetic intensity, but also to the stories that have developed around its origin: linked to the convent of the Benedictine nuns of San Placido in Madrid, it is said that Philip IV commissioned it from Velázquez as a votive offering in penitence for a sacrilegious love he had felt for a young nun.

The painting is infused with serenity. The sensation of peace is increased by the few drops of blood and the feet that rest on a block of wood, held by nails, as Pacheco recommended in his treatise *Arte de la pintura* (The Art of Painting). Christ's limbs and body are beautifully modeled and illuminated by a clear light from the top left corner, as in paintings by Caravaggio, but no shadows are evident as the cross and its figure are set against an almost completely black ground. Christ's body is highlighted using pale flesh tones that contrast with the darkness behind and has parallels with the classical canons Velázquez had encountered on his recent trip to Italy. The drama is concentrated in the hanging head and lock of hair that falls from the crown of thorns. It is said that the artist was irritated and painted this part of Christ's hair quickly, thereby covering half of the face. An unusual but learned feature of the painting is the inscription 'Jesus Nazarene King of the Jews' in Hebrew, Greek, and Latin rather than the usual abbreviated version INRI.

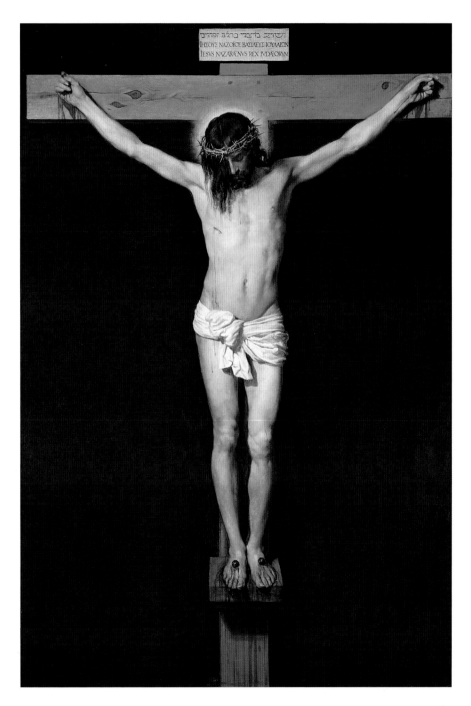

1631
Oil on canvas, 244 × 203 cm
Orihuela, Museo Diocesano
de Arte Sacra

The scene shows the moment at which Saint Thomas—still a novice and exhausted by the struggle to resist temptation, represented by a prostitute whom he forced to flee by threatening her with a firebrand—is comforted by two angels. One kneels beside him and holds him up, the other stands behind rapt in contemplation and preparing to wrap a white sash around Thomas as a symbol of chastity.

The composition is perfect: in the foreground there are books, a stool and the inkpot that refer to the saint as a scholar and writer; the space, with the fireplace and door that opens onto the background where the temptress prepares to leave, is beautifully composed; and the contrast between the vulgarity of the prostitute and the nobility of the standing angel is exquisite.

No information exists about the history of this painting. It was conserved in the sacristy of the church in the ancient University of Orihuela, which was under the direction of Dominican fathers, and was probably painted as a commission. Saint Thomas was the patron saint of the university and a scholar who belonged to this order, and the theme of the painting would have been an excellent counsel to the students.

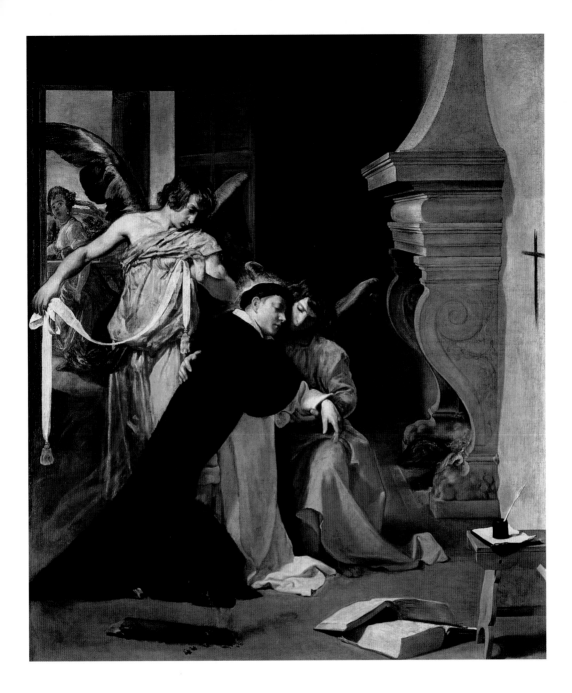

Queue Isabel

c. 1632
Oil on canvas, 128.5 × 99.5 cm
Vienna, Kunsthistorisches
Museum

Isabel of Spain, daughter of the French king, Henry IV, and Marie de' Medici, married Philip IV in 1615 when he was still the Infante. In the period between 1631 and 1633 Velázquez painted Isabel's portrait on several occasions.

This canvas was commissioned from Velázquez by the king and painted in 1632. It was given to his sister, the Infanta María Anna who a year before had married her cousin Ferdinand Habsburg, the king of Hungary who later became emperor of Austria. From the Austrian imperial house it moved to the museum in Vienna, perhaps during the first quarter of the nineteenth century. Originally the portrait was probably full-length. Today many art critics argue that the painting includes the work of several of the master's pupils.

The portrait features the characteristic motif of the necklace wrapped around the shoulders. This detail is particularly evident in the workshop copy in Chicago that was at one time part of the Sackville Collection in London. It then passed to the art dealer J. Boechler of Munich, where it was purchased by Max L. Epstein in 1927 and catalogued by Mayer as a Velázquez original.

Velázquez portrayed Isabel in another version now in a private collection in New York, in which he painted the queen's dress with great refinement. In addition to the splendor of the material, Velázquez was attracted by the reflections on the black fabric, which he painted with brilliant highlights and in a profusion of tones.

Isabel of Spain was also portrayed on horseback in a painting of 1634–1635, later retouched by the artist, which is now in the Prado in Madrid.

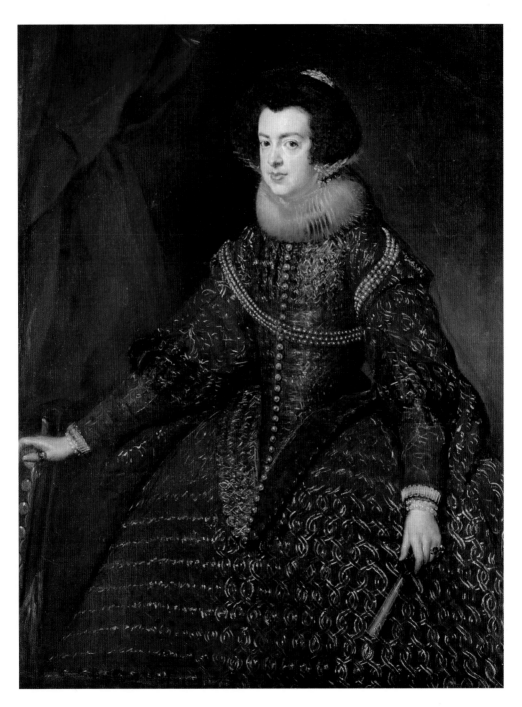

The Jester Pablo de Valladolid

1632–1633
Oil on canvas, 209 × 123 cm
Madrid, Museo Nacional
del Prado

Pablo de Valladolid was known as the 'man of pleasure' and it was his task to entertain the royal family at court. The figure in the painting stands in a declamatory pose and has a completely normal expression, and thus might be mistaken for an actor.

The Prado catalogue describes the figure as "dressed completely in black, well drawn, painted against a pale background, creating a fine effect." The background is a great novelty: Velázquez did not want to divide the floor and backdrop even with a line, a notion that would have been normal for a heavenly apparition but which was completely new for a portrait. In 1865 Édouard Manet wrote from Madrid to a friend: "Perhaps the most amazing work of painting ever produced is the one called *Portrait of a Famous Actor at the Time of Philip IV*. The background disappears. Air surrounds the figure, who is dressed only in black and is full of life."

Manet, who called Velázquez the *peintre des peintres* (painter of painters), drew on this technique in his work the *Fife Player* (Musée d'Orsay, Paris) of 1866. The young boy stands in a neutral space joined to the floor only by his own shadow.

In Velázquez' painting, the jester stands like an actor in a particularly undefined space in which there are no indications of a floor. Artists of different eras, including Goya, were admirers of this masterpiece, in particular the luminous grey tones of the background which over time has been transformed into a rather dull ochre.

As the rigid court etiquette prescribed, the man's dress was black, with top and sleeves either embroidered or in segments, a white ruff, and an elegantly wrapped cape. Actors were not allowed to wear clothes embroidered with silver thread or lace collars, but jesters were permitted to dress a little more freely.

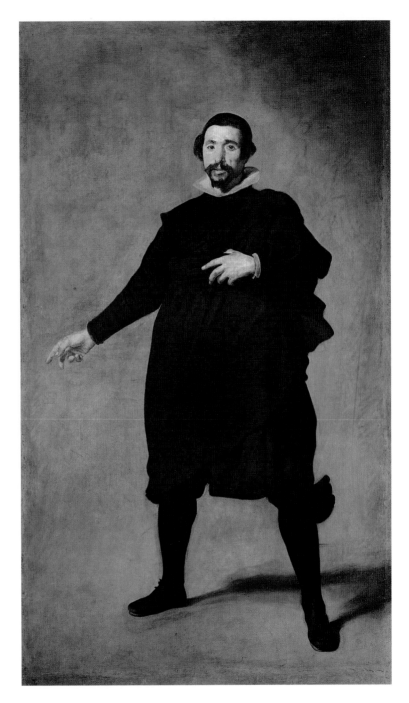

The Jester 'Don Juan de Austria'

1632–1633
Oil on canvas, 210 × 123 cm
Madrid, Museo Nacional
del Prado

Velázquez painted jesters with great ability in an attempt to portray their inner self rather than their physical deformities. The result was a critical and passionate image of their incongruous world, sadly represented in this painting. 'Don Juan de Austria,' dressed as a soldier, bears the name of the great military commander and son of Charles V who distinguished himself in the Battle of Lepanto in 1571. This famous man later became the symbol of the decline and crisis that Spain was experiencing at the time this painting was made.

The Prado catalogue titles the work *The Jester 'Don Juan de Austria'* because his real name is not known. The nickname may have been intended ironically: it was common to give the names of kings or princes to people of modest background who were taken into the protection of the palace.

The portrait is undoubtedly one of Velázquez's most skilful in terms of technique. The nobility of the pose and bearing of the figure is so great that it convinced the Accademia di San Fernando, to which the painting belonged from 1816 to 1827, that the figure portrayed was the Marquis of Pescara. With his magnificent and somewhat antiquated clothes, enormous moustache, the tragicomic head crowned by a plumed hat, his thin legs and feet between scattered trophies (which are more reminiscent of market items), and with a fictitious naval battle glimpsed through the open doorway, this don Juan of Austria is the counter-figure of the young victor of Lepanto—ridiculous but moving. Velázquez never painted more effectively or with such delicacy and self-confidence as in this portrait.

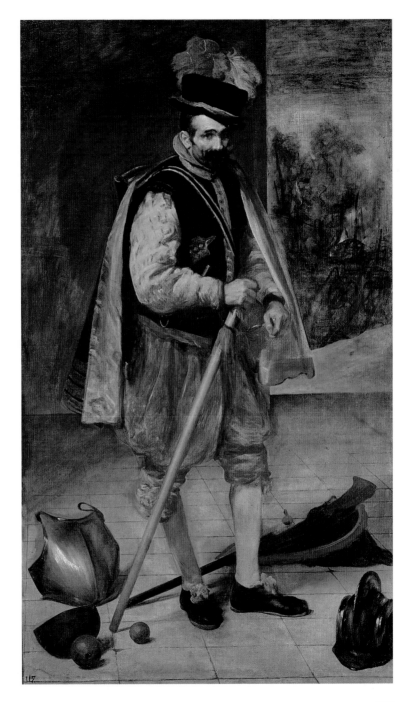

117

The Count-Duke of Olivares on Horseback

1634
Oil on canvas, 313 × 239 cm
Madrid, Museo Nacional
del Prado

Don Gaspar de Guzmán, son of the second Count of Olivares, was born in Rome on January 6, 1587. He was appointed prime minister by Philip IV and rewarded with the title of duke, to be held in addition to his title of count. However, having won the king's esteem and become Philip's protector, the count-duke fell into disgrace in January 1643, though not dragging the king with him on his fall. Olivares was distanced from the court and died in 1645.

This equestrian portrait was executed at the height of Olivares' power and is one of Velázquez's most expressive. It is not a member of the royal family portrayed, rather the man who often turned out to be more powerful than the king himself. Velázquez represented this power by making the painting an equestrian portrait, an honor generally reserved for heads of state.

Olivares was renowned as a rider; here he is portrayed with a plumed hat, a baton of command, and wearing armor with gold decorations. The painting shows him preparing to jump diagonally from a height into the depths of the canvas. Seen from behind, the figure and horse are oblique to the canvas and fill its entire width. With his head turned to the side, the count-duke looks down at the observer from on high. The head of the magnificent horse is turned towards a broad plain below from where we see the puffs of gunpowder, smoke from fires, and a battle in miniature taking place. In contrast to what has several times been supposed, this is not a particular battle, but a representation of the military genius of the man who had guided the armies of the king to innumerable victories.

At bottom left a sheet of white paper can be seen. The artist, who generally neither signed nor dated his paintings, often inserted blank sheets of paper in his works.

110

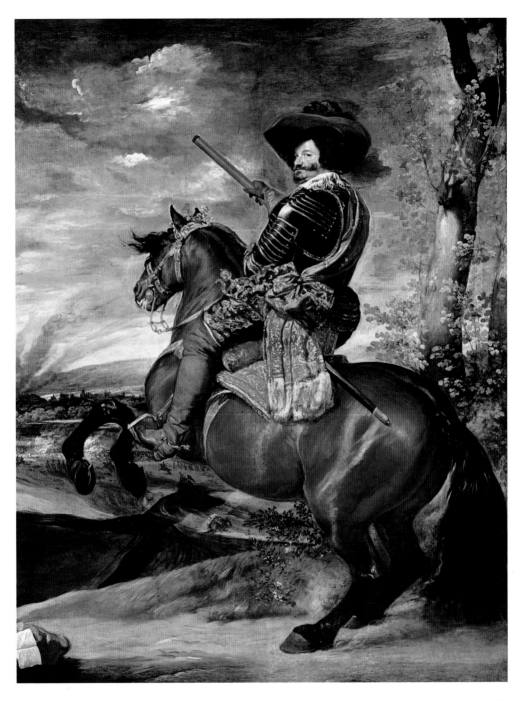

1634–1635
Oil on canvas, 191 × 126 cm
Madrid, Museo Nacional
del Prado

During the years in which he worked at the Torre de la Parada (the royal hunting lodge in the hills of El Pardo), Velázquez had the task of portraying the members of the royal family wearing hunting clothes and with their animals in the landscape of the Sierra de Guadarrama.

Philip IV was born on April 8, 1605 and ascended to the Spanish throne on March 31, 1621 at the age of sixteen. Velázquez, born in 1599, was almost of the same generation as the king, and it is natural that he wished to surround himself with young contemporary artists. The king was very respectful and understanding of the innovations Velázquez brought to painting. At the time of this portrait, the artist had reached his full maturity and was absolutely sure of his abilities.

The king is shown in a relaxed pose in front of a dark oak tree, with a dog at his feet. He wears a green and brown hunting outfit made to withstand bad weather, yellow gloves, and leather leggings. As usually happened, the portrait is not official in nature, but the skill of the painter is such that Philip's royal dignity emerges despite the painting's casual and informal nature. In his elegant and proud simplicity, Philip IV is shown so superior to common mortals that he does not need symbols to emphasize his regality.

Velázquez's ability to paint hunting dogs should also be mentioned. Philip's black-faced mastiff is painted with exceptional simplicity, fluidity, and vitality. It sits calmly and watches the observer with an air of alertness. The dawn landscape is superbly rendered in green and silver tones. The tree in the foreground and those behind on the right form a frame that emphasizes the long, pale face of the king.

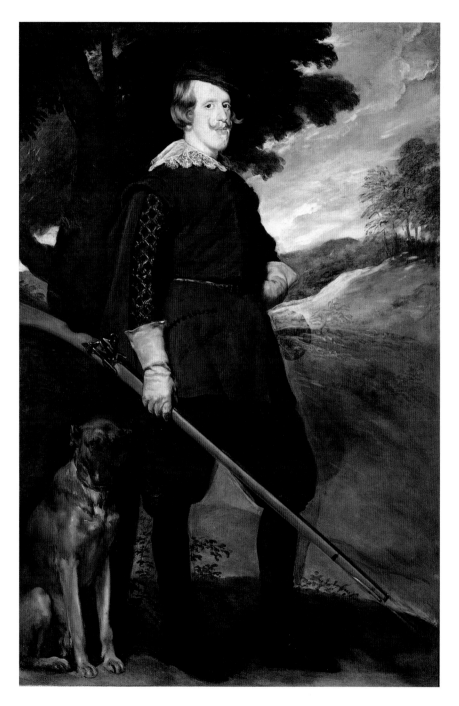

The Surrender of Breda
(Las Lanzas)

1634-1635
Oil on canvas, 307 × 367 cm
Madrid, Museo Nacional
del Prado

The Surrender of Breda exalts manifestations of humanity over the horrors of war. The struggle for control of the Low Countries proved that Spain was to be a future world power. The most important stronghold in the southern Low Countries—the fort at Breda in Brabant—was a strategic military outpost, and the best Spanish commander of the Thirty Years War, Ambrosio Spinola, a rich Genoese aristocrat, was well aware of its importance. The commander of the fort was Justin of Nassau, who was equally famous as a military leader in Europe.

The handing over of the keys of the city of Breda took place on June 5, 1625. Velázquez painted the episode for the Retiro ten years later in a version that makes the actual moment tangible to the observer. The defeated army was allowed to leave the city with its weapons and flags without being humiliated. Spinola waited with several nobles on horseback near the gates of the city and magnanimously saluted the Dutch general as he left the fort, followed by his wife in a carriage.

In Madrid the news of the victory was welcomed with great enthusiasm and relief. A painting by Calderón de la Barca of the siege of Breda was presented in the capital in November of 1625. The scene in that version shows Spinola as he says to his adversary the proud but humble phrase that later became a proverb, "The valor of the vanquished makes the glory of the victor." It is probable that the young Velázquez saw the painting at court; nine years later he transposed the same event to canvas after having made several preparatory studies. Constantly unsatisfied, he made alterations and repainted sections, but the final work seems infused by an infinite lightness: it is one of the most famous and perfect paintings of war in the history of art.

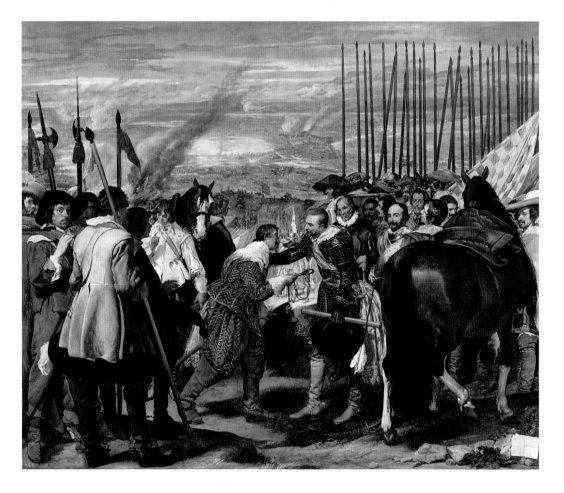

Saint Anthony Abbot and Saint Paul the Hermit

1634–1660
Oil on canvas, 257 × 188 cm
Madrid, Museo Nacional
del Prado

It is extremely difficult to date this painting. López Rey and other experts have hypothesized that it was painted around 1634, Bardi suggests 1642, while others judge it to have been painted during even later years.

Originally the canvas had an arched frame, as is apparent when examining the upper section of the painting. From an iconographic standpoint, Velázquez has depicted several religious episodes in a single scene. The main event takes place in the foreground: a rook flies down towards the two saints with a piece of bread in its beak. In a niche in the rock behind them Saint Anthony knocks at the door of the hermit's cave. At bottom left two lions dig the grave of Saint Paul, whose body is watched over by his hermit companion, Saint Anthony, kneeling beside him. Finally, in the background, the meeting between the centaur and Saint Anthony is shown.

The origin of this iconography is a source of debate among art historians and critics. It is thought that Velázquez may have drawn inspiration from a fresco on the same theme by Pinturicchio in the Borgia apartments in the Vatican or from a famous engraving by Albrecht Dürer.

Once more the Spanish master demonstrates his love of nature with a landscape typical of the granitic caves of Guadarrama, which were very well known to him.

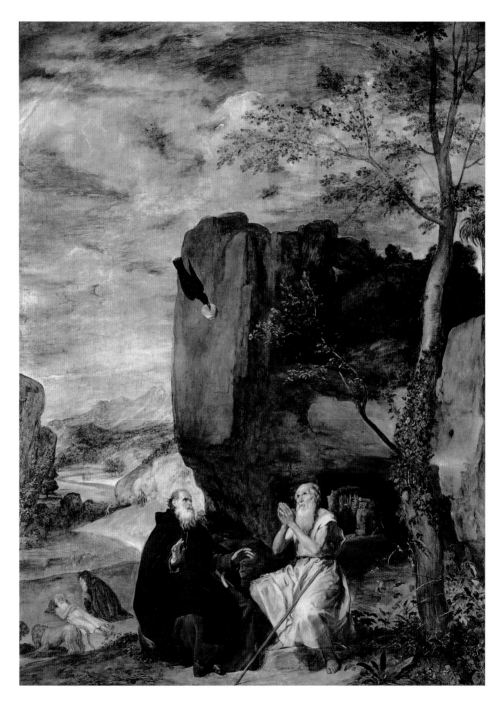

1635
Oil on canvas, 67 × 54.5 cm
St. Petersburg, The State
Hermitage Museum

This portrait is the most self-assured that Velázquez painted of the Count-Duke of Olivares. Against a neutral background, we see the simple half-length image of Olivares with his face swollen and tired (compared to other important portraits of him from the mid-1620s), decidedly aged and burdened by the responsibilities of power. His nose is flattened and his mouth—with his lips drawn back and tightly shut, as though he had no teeth—is drawn in a small, bitter smile. The look he proffers the viewer is suspicious.

This painting is thought by many art historians to capture perfectly the decline of the count-duke who, after many years of struggle and government, wrote as early as 1640, "I have only breath left to die, in the midst of so many and such deep difficulties and adversity."

Olivares wears a simple black doublet and a white collar. The color range is limited to blacks and a few silver-greys. The ground is silver-grey enlivened by a few touches of yellow and olive green. Olivares's cheeks have been rendered in almost cold tones of grey and his lips have only a tiny touch of red. A black band covers the Cross of Alcántara sewn on his coat, his hair is dark brown, and the collar is a bluish grey.

This painting in St. Petersburg was almost certainly a live study that was used as a model for the workshop. It was repeated in a slightly different version in miniature on copper that can be seen in the royal palace in Madrid, and in various canvases that are either simple copies or workshop paintings.

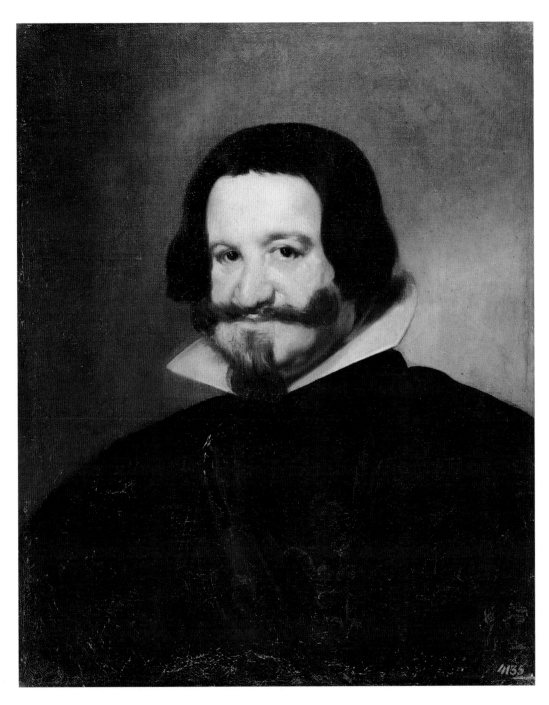

c. 1635
Oil on canvas, 209 × 173 cm
Madrid, Museo Nacional
del Prado

Prince Baltasar Carlos was the son of Philip IV and Queen Isabel Bourbon. He was born in Madrid on October 17, 1629 and died very young in Saragoza on October 9, 1646. The painting was made around 1635 for the Salón de Reinos in the Palacio del Buen Retiro.

According to Elias Tormo, Velázquez designed the perspective in the work to be viewed above the door in the Hall of Realms, high above the observer. This is why the belly of the pony appears out of proportion.

Goya made an engraving of this painting. There are also numerous copies, many of mediocre quality, while other versions with different compositions show the prince on horseback with the Count-Duke of Olivares in the royal riding school.

In a typical stroke of brilliance, the finely graduated colors of the landscape depict the transitions between the different planes and atmospheric stratifications, and show the snowy heights of the Sierra de Guadarrama as slightly bluish due to the haze created by the distance. The clouds are a further reminder of Velázquez's ability to paint from life and evoke the purity and clarity of the air in Madrid and its surrounding area.

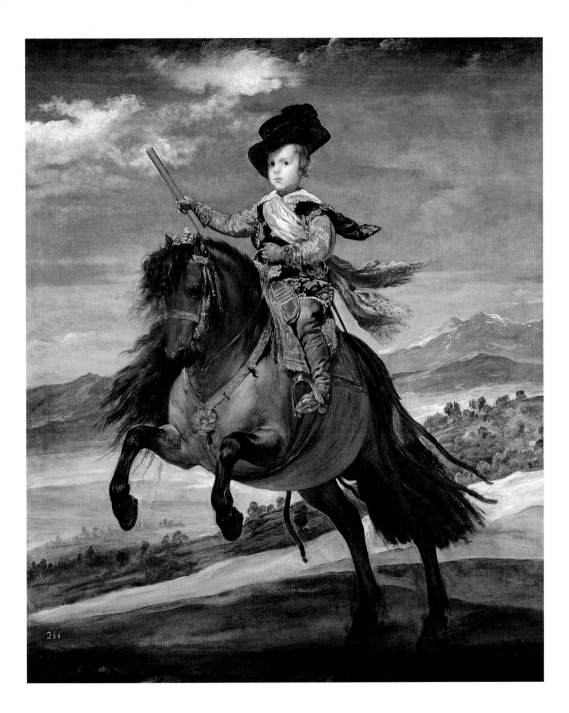

The Sculptor
(Juan Martínez Montañés?)

1635–1636
Oil on canvas, 109 × 107 cm
Madrid, Museo Nacional
del Prado

The identity of the figure in this lovely portrait and, therefore, its precise date are contentious, but its authorship has been proven. The prevalent opinion is that the subject of the portrait is the great sculptor Juan Martínez Montañés, a friend of Francisco Pacheco.

Montañés was born in Alcalá la Real on March 16, 1558 and died in Seville, his adopted city, on June 18, 1649. The most important period of his career was between 1605 and 1620, when he inaugurated his famous *Cristo de la Clementia* in the sacristy of Seville's cathedral and his *Immaculate Conception* in the parish church of El Pedroso.

The Sevillian sculpture that developed before the local painting style noticeably affected the painters of Velázquez's generation and Velázquez himself during his Sevillian period (*Immaculate Conception*, 1618, National Gallery, London).

Velázquez portrayed Montañés while the sculptor was probably studying Philip IV for his own work of art. Montañés is shown in a position similar to the one that Velázquez himself adopted in *Las Meninas*, holding his work-tool in the air (a modeling stick for the sculptor, a brush for the painter) rather than on the work itself. The purpose of this is to indicate that the resulting artwork depends on the artist's 'internal design', and thus that sculpture and painting are on a higher level than mechanical art which, on the contrary, draws on the world of real 'Art'.

The outstanding features of the painting are the man's noble face, his penetrating gaze, and the white collar that is depicted so that every detail of the fabric is perfectly highlighted. A neutral background—darker around the sculptor's head and lighter close to his work—focuses our attention on the salient features of the portrait: the analytical eyes, thoughtful brow, and hand ready to obey the sculptor's thoughts.

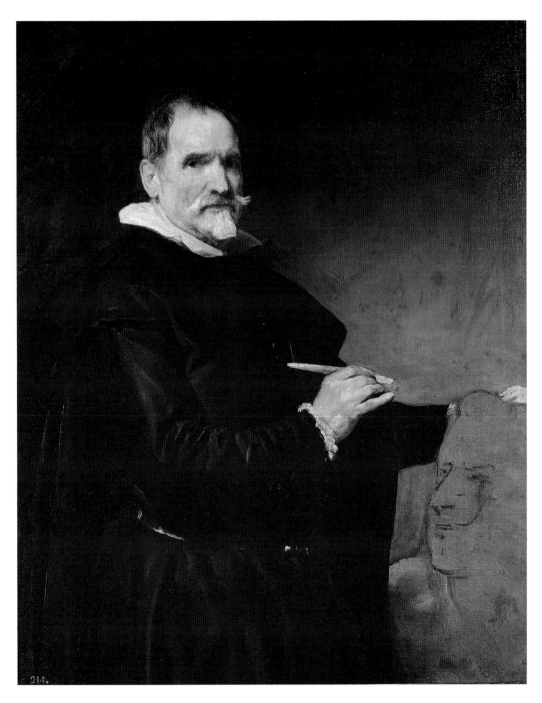

214.

The Dwarf Juan Calabazas ('Calabacillas')

1638–1639
Oil on canvas, 106 × 83 cm
Madrid, Museo Nacional
del Prado

The dwarf portrayed sits on the ground with difficulty owing to his deformity. He wears a green suit with cuffs and collar trimmed with gauzy Flemish lace that has been painted with the fluency and care that Velázquez reserved for ornamentation. To his left is a gilded, shining gourd of the highest quality, and to his right what could be a large wine jug or perhaps a second gourd.

The name *Calabacillas* (from *calabazas*, meaning 'gourds') was in all probability a nickname that alluded to the man's unfortunate physical condition. At one time the jester was in the service of the Cardinal-Infante don Ferdinand of Austria, but following Ferdinand's departure for Flanders in July of 1632 he joined the employ of King Philip IV. As Calabacillas died in 1639, the portrait must have been painted before that date.

The painting of the jester, with his broad forehead, is fully realistic: he has a smiling countenance but clearly suffers from a squint. The portrait is undoubtedly one of the most distressing depictions of reality painted by Velázquez.

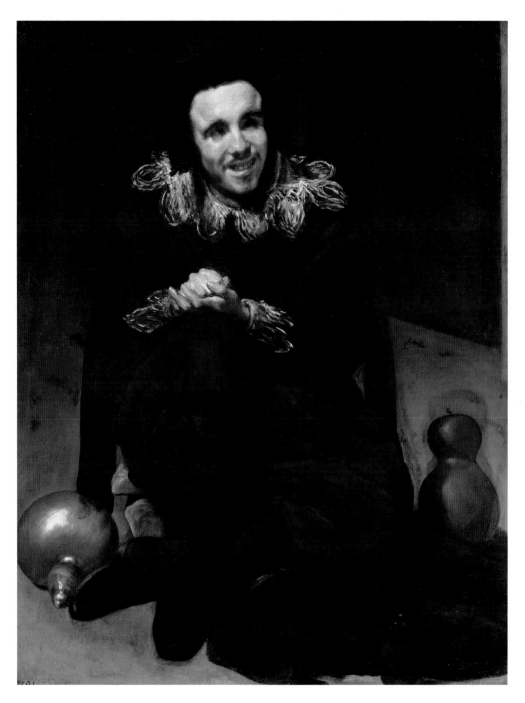

Menippus

1639–1642
Oil on canvas, 179 × 94 cm
Madrid, Museo Nacional
del Prado
At top left 'MOENIPPVS'

There is full agreement that this painting is by Velázquez even if it is not signed, as was the artist's custom, but there are differing opinions on its date. The mastery of the technique suggests that it could have come from the last period of Velázquez's life, but the Prado catalogue tells us that it was painted around 1639–1640 for the Torre de la Parada (Philip's hunting lodge), as were *Aesop* and *Mars*, of similar size. Certainly Menippus's head indicates remarkable maturity and an extraordinary artistic fluidity and ease.

As for identification of the figure in the painting, an inscription, which seems to be by the painter, states that the portrait is of 'Moenippus'. Menippus was a Greek philosopher born in Gadara around 270 BC; he was the author of a number of satirical poems against the Epicureans and a member of the Cynic school.

The grey-haired figure portrayed is about the same age as *Aesop*. Tall, thin, and seen in profile, he gazes at the observer with a mocking expression. He is completely wrapped in an old greenish-blue cloak that hangs down to his feet and which he holds with his left hand at chest level. Large, worn leather boots and threadbare socks cover his feet and part of his legs.

At the philosopher's feet Velázquez masterfully painted an open book and a smaller one, an octavo, bound in parchment and resting against a roll of paper. These are the emblems of a philosophy that is of no use for living and which the Cynic philosopher scorned. In the background on the right, a clay amphora stands precariously on what seems to be a plank resting on two rolls of paper, perhaps an allusion to a physical problem or to the instability of life. The brightness of the floor seems to extend to beyond the frame of the painting, as would happen in *Las Meninas*. The rather bright brown background is emphasized in the bottom half where the ochre amphora stands.

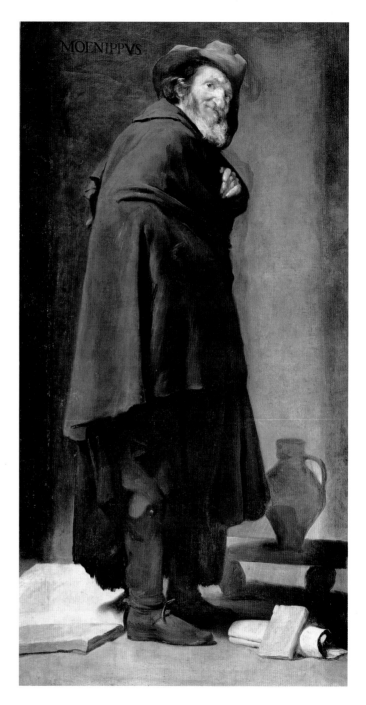

Aesop

1639–1642
Oil on canvas, 179 × 94 cm
Madrid, Museo Nacional
del Prado
At top right 'ÆSOPUS'

Like *Menippus*, this painting was executed between 1639 and 1642. As a mandate from his patron, Vincenzo Gonzaga, Duke of Mantua, in 1603 the Flemish painter Pieter Paul Rubens painted *Democritus Laughing* and *Heraclitus Crying* while he was the guest Philip III in Spain. Both works were at first hung in the Torre de la Parada, the royal hunting lodge, and later moved to the Prado. Their pictorial style and naturalistic vigour, typical of Flemish art, indubitably influenced Velázquez as he prepared to paint *Aesop* and *Menippus*. Instead of simply imitating Rubens' models, he chose to represent the famous Greek philosophers as two impoverished *hidalgos*.

Gazing intently at the observer with an unequivocal candor, Aesop, the great satirical poet whose fables were a source of inspiration to La Fontaine, is shown here with an ironic expression that suggests his disappointment, though not without indulgence, with humanity. Rather than depict an ancient Greek poet in an image taken from the past, Velázquez once again portrayed the individual as a man of his own time, using subjects taken from the common people in the same way Cervantes did in his *Novelas ejemplares*.

In this work we see once more one of the main characteristics of Velázquez's corpus: though his models belonged to his own time, they transcend its limits to exist in a timeless dimension. His subjects would have been perfect both for the centuries that preceded the artist's life and for those that followed.

His sureness in applying a dense impasto to the canvas in broad brushstrokes anticipated the style that would also characterize Manet's hand. Browns dominate the range of colors used and accentuate the simplicity of the subject.

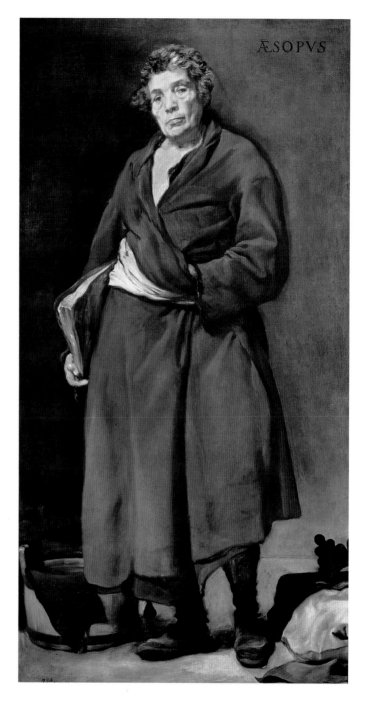

1640

Oil on canvas, 179 × 95 cm
Madrid, Museo Nacional
del Prado

The man in this painting is seated on a red cloak with only a blue cloth around his hips and a helmet on his head. His moustache, like that of the soldiers in the *Tericios* seen in the *Surrender of Breda*, seem to emphasize his expression of melancholy in a grotesque manner. His head rests on his left hand somewhat in imitation of Michelangelo's sculpture of the *Pensieroso* (Tomb of Lorenzo de' Medici, Nuova Sacrestia di San Lorenzo, Florence). As for the nude, several Roman statues have been suggested as sources, including the *Ares Ludovisi* (Museo Nazionale Romano, Rome), though the work was unquestionably painted from life.

Analogies can also be found with the work of Rubens in the bright, reddish flesh tones and the musculature of a mature man. This maturity does away with any solemnity and confers the god with a degree of humanity. In his right hand, hidden by the cloak, he holds a wooden club or staff. At his feet lies a modern sword with an enormous hilt, a section of armor, and a parade shield.

As in the *Jester 'Don Juan de Austria'*, Velázquez has depicted the symbols of war in the foreground, but here they are used to demonstrate the extent of the absurdity and melancholy of this vision of the god, which is exactly the opposite of the mannerist iconography of Mars in Italian art.

With *Aesop* and *Menippus*, this painting was one of a series of characters taken from classical tradition and painted to be hung in the Torre de la Parada, where it remained until 1703. It appeared later in the inventories of the new royal palace (1772 and 1774), in 1816 it was passed by Ferdinand VII to the Academia de San Fernando, and from there it moved to the Prado in 1827.

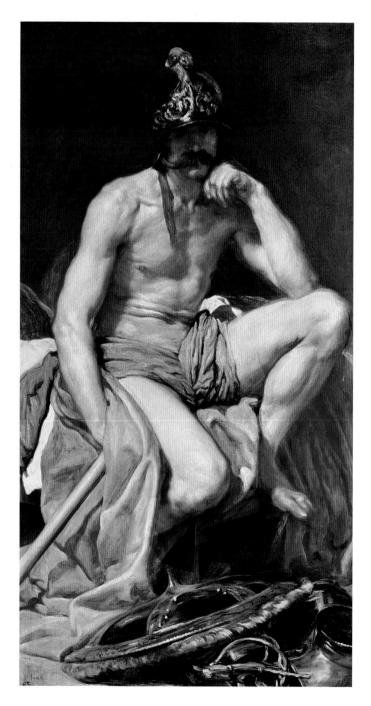

1640–1645

Oil on canvas, 142 × 107 cm
Madrid, Museo Nacional
del Prado

After working in Seville first with Herrera and then Pacheco, Velázquez began as his own master with the help of a few assistants, for the most part apprentices. The best known were Juan de Pareja, whom Velázquez taught to paint, and Juan Bautista Mazo, his official copyist. Mazo is attributed with several copies of his master's paintings, the completion of paintings that Velázquez perhaps did not finish in person, and of works whose authenticity or attribution remain in doubt. This canvas is a typical example.

Because an English dwarf was given by the Duke of Windsor to Philip IV and, above all, as Palomino honored the beauty of Velázquez's painting, attribution to the master seems sure even more so given that it appears in eighteenth-century inventories of the Madrid court (it was part of the Prado collections since the museum was founded in 1819). The identity of the man as don Antonio el Inglés, however, was no longer tenable, since it was discovered that he had died *loco y enamorado* (crazy and in love) in 1617. In addition, the painting is incomplete and, in consequence, difficult to judge. As a result, Allende-Salazar excluded it from the number of Velázquez's works and attributed it to Juan Carreño de Miranda, but this, like Gerstenberg's attribution of the painting to Mazo (1957), was not generally accepted. Nonetheless, exclusion from Velázquez's catalogue raisonné has been supported by López Rey, who considered it a work by a seventeenth-century *pasticheur*.

Supporters for its attribution to Velázquez, datable before 1650, argue against it being inspired by the *Dwarf Belonging to Cardinal de Granville* by Antonio Moro (Louvre, Paris), while the dog reappears in the *Cacería del Tabladillo* by Mazo (Prado, Madrid). It is difficult to believe that Velázquez was ever the copyist of Mazo, and the pictorial quality does not seem worthy of the master.

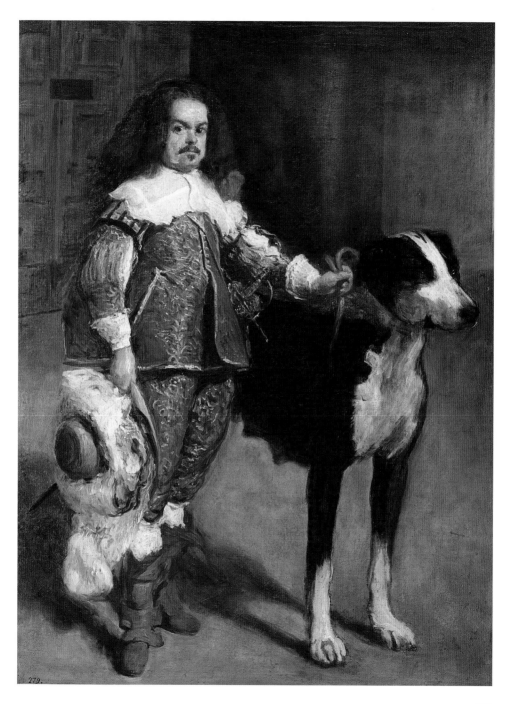

279.

133

The Coronation of the Virgin

c. 1641–1644
Oil on canvas, 176 × 134 cm
Madrid, Museo Nacional
del Prado

According to López Rey this painting dates from 1644, whereas others claim it is from the period 1641–1642, as it was used later as a model for the version by Jusepe Martínez that was completed in 1644 for the Cathedral of Saragoza.

With regard to the composition, some art historians have claimed that a woodcut by Dürer (*Assumption*) and similar themes tackled by El Greco significantly influenced Velázquez. The figure of the Virgin may have been inspired by the *Purissima Concepción de Nuestra Señora la Virgen María* by Montañés in Seville's cathedral.

Even if the composition bears similarities with the works and tradition of El Greco, the forms and colors of the figures have nothing in common with those of his great predecessor. Those of El Greco were lengthened and curved in accordance with a highly refined aesthetic of arabesques, and almost distorted in their desire to express the degree of their mystical intensity.

Velázquez's figures are treated with restraint. Their faces and bodies are so realistic that a nineteenth-century critic, Anna B. Jameson, considered it a grave defect to depict the baldness of the Eternal Father. In contrast with the interplay of whites, blues, and golds typical of El Greco, Velázquez uses a palette predominated by reds and violets to put further emphasis on the mantle worn by the Virgin.

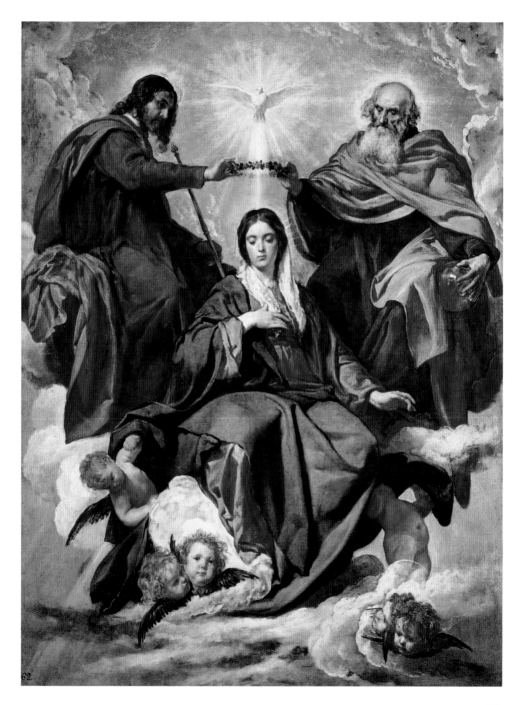

The Dwarf Francisco Lezcano
('El niño de Vallecas')

1642

Oil on canvas, 107 × 83 cm
Madrid, Museo Nacional
del Prado

Francisco Lezcano was a dwarf in the service of Prince Baltasar Carlos and a functionary in Palacio Encinillas. He beat his wife, having been jealous of don Diego de Acedo, another dwarf also painted by Velázquez.

In this painting Lezcano is dressed in green, the color of hunting dress, which matches the landscape of the Sierra de Madrid in the background (the same as that seen in the portrait of *Prince Baltasar Carlos as a Hunter*, 1635–1636, Prado). The shelter or cave in which he sits is a setting suitable for contemplation. A wrinkled but clean white shirt is visible beneath his jacket, and his short arms emerge from his heavy cloak. His right leg is extended to display his physical abnormality and the bottom of his built-up shoe, and his left sock falls down over his ankle. The dwarf's clothes are not low quality like those of a beggar, but the impression of untidiness that they give is representative of his confused state of mind. His meek and inexpressive face is raised slightly upward towards the sun.

He holds something in his chubby hands. Some think that it is a flat brush with a short handle that the painter gave him to keep him occupied, while others consider it a chunk of bread or a shard of tile. Pantorba, on the other hand, believes it is a pack of playing cards. Supporting this idea, some suggest that the cards were useful to the painter to help give life to the posture and create the psychological atmosphere of the painting. Indeed, the stubby fingers of the dwarf seem positioned to shuffle the deck or deal the cards.

In 1964 Dr. Moragas diagnosed that the dwarf "suffered from cretinism with oligophrenia and has the customary characteristics of a cheerful spirit and dog-like loyalty." "His face has a satisfied expression indicated by his half-closed lids and half-open mouth, which seems close to a smile." Francisco Lezcano died in 1649, three years after his master, who passed away in Saragoza in 1646.

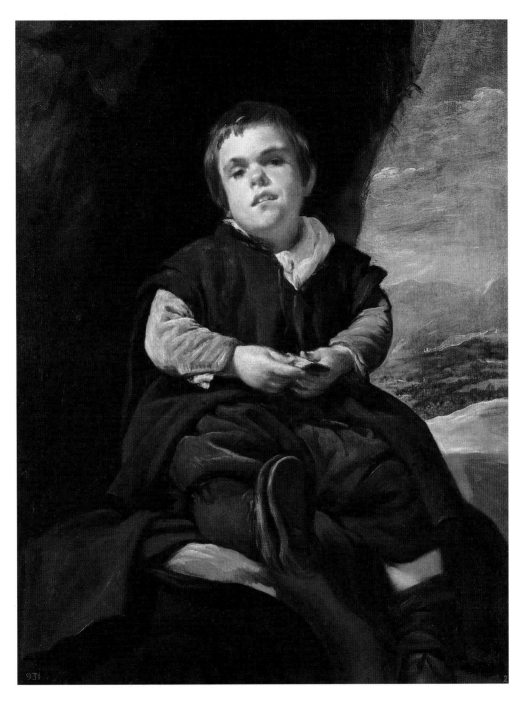

1644
Oil on canvas, 107 × 82 cm
Madrid, Museo Nacional
del Prado

It is thought that this painting was made in Fraga during the Aragon expedition following the Catalonian uprising. Don Diego de Acedo was not a jester, but was a palace functionary. His responsibility was the stamp with the royal signature, a post to which the enormous book in his hands and the smaller, loose-leafed one on the table may refer. The glue pot to stick the pages back in again stands on top of the book. Two other books on the left of the picture may indicate that don Diego had a certain literary inclination.

The dwarf is thought to have entered the palace in 1635. In the summer of 1642, while the royal court passed through Molina de Aragón, a musket ball fired by a soldier, perhaps aimed at the Count-Duke of Olivares at the start of his downfall, wounded the dwarf who was fanning him.

Unquestionably this is one of Velázquez's best portraits. Dressed elegantly as a cavalier—with a goatee beard, a combed moustache, decorated trousers, black shoes and socks, a broad black hat, black brocade coat, and a starched collar—he is painted against the backdrop of a mountainous landscape. His has an intelligent face and broad forehead that his hat does not hide, but his expression is a little distant and his gaze thoughtful and removed. His small, delicate hands finger a large book which with the other volumes and the glue pot form a still-life. The restrained colors are predominated by whites, blacks, and bluish greys. The contrast in size between don Diego and the book he holds is rendered in a natural manner. X-ray examination has revealed that the man's head was painted over another.

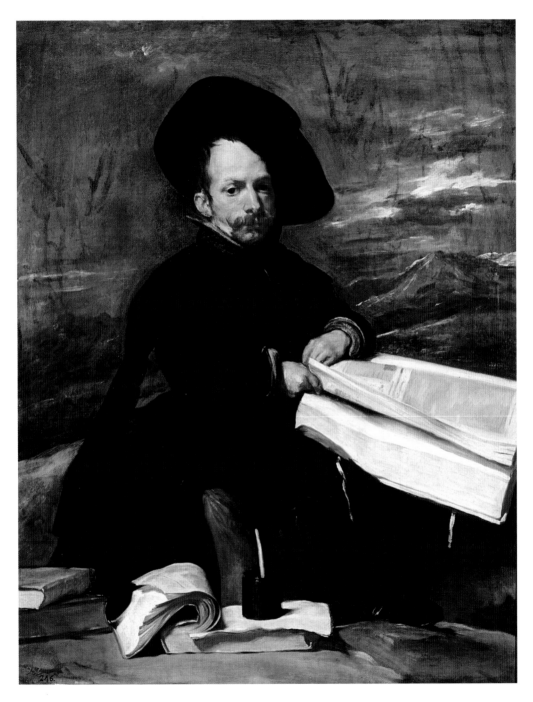

139

The Dwarf Sebastián de Morra

c. 1644
Oil on canvas, 106 × 81 cm
Madrid, Museo Nacional
del Prado

This portrait is indisputably one of Velázquez's most outstanding paintings of which the authorship is unquestioned. The beauty of the golds, crimsons, whites, greens, and blues are the equal of the portraits of the princes and princesses of his last decade.

At one time the dwarf was employed by Cardinal-Infante don Ferdinand of Austria in Flanders but, on the death of his master, he wished to return to his native Spain, and in 1643 entered the service of Prince Baltasar Carlos. The prince appreciated Sebastián de Morra so much that in his will he left him a silver dress-sword with shoulder strap, a dagger, a knife, a sword, and two knightly insignia decorated with a lily motif. Given the prince's love of hunting since childhood, it is very probable that the dwarf accompanied him on these outings, and that would have been the reason for the legacy of these weapons.

The clothes worn by the dwarf are made of green cloth, like that given by the dukes to Sancho Panza in *Don Quixote*. Over his jacket don Sebastián wears a sleeveless jacket of gold and crimson worthy of a prince, which was probably a gift from his second master. The cuffs and collar are of the gauzy Flanders lace that the law of austerity forbade gentlemen to wear, but de Morra enjoyed the favor of the prince and thus was considered above this ban. He died in October of 1649.

The dwarf's face wears an expression of deep sadness, like that of a fully-grown man, a note that jars with the shortness of his legs. These are painted foreshortened on the ground with the soles of his shoes in the foreground, thus accentuating the impression of the figure as a disjointed puppet, but at the same time diminishing our awareness of his pitiful lameness. His gaze, framed by his well-combed fringe, thick beard, and upturned moustache, watches the observer intently. His stump-like hands closed inwards are a moving feature of the portrait.

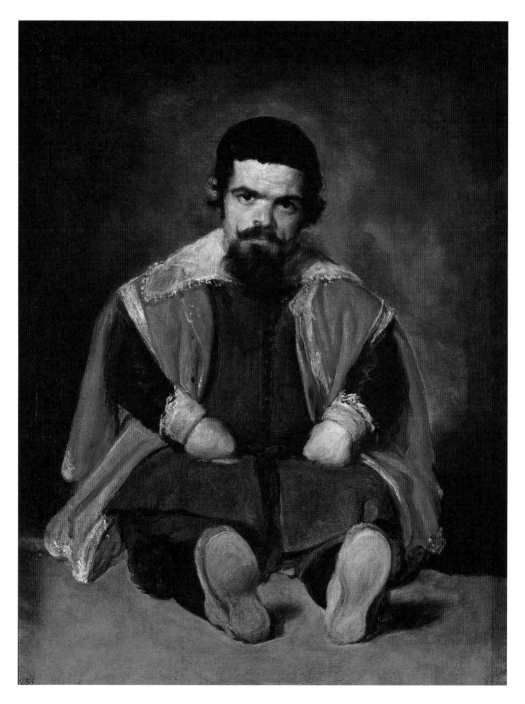

Juan Francisco de Pimentel, Count of Benavente

1648
Oil on canvas, 109 × 88 cm
Madrid, Museo Nacional
del Prado

This painting is usually dated to 1648, and, according to Pantorba, between April and November, as it was on April 3 that Pimentel was awarded the Order of the Golden Fleece (a necklace decorated with a gold ram) which he wears in the portrait. In November Velázquez left for Italy, and it was probable that on his return in the summer of 1651 the count was no longer at court because he died in Valladolid the following year.

The painting is only half-length, but as it was stretched for many years and cut on all four sides, it may once have been larger, perhaps even full-length. The count is seen in three-quarter profile facing a table where his baton of command and helmet lie. His gloved right hand rests on the helmet while his left hand is placed on the pommel of his sword richly inlaid with gold. The crimson sash across his chest indicates the count's rank of general; this colorful feature lies at the centre of the composition, which is illuminated by the blue sky on the right behind the dark flap of a tent. The count's stiff, starched collar seems to hold up his sturdy neck and noble head. His grizzled hair is tied up on his forehead, and his white beard and moustache contrast with his dark eyebrows and eyes. The general's gaze is steady, but not directed at the observer: it seems to pass us by without recognizing our presence.

Don Juan Francisco de Pimentel was also the Count of Luna and Mayorga, Lord of Herrera, senior judge of the Asturias, and president of the Council of Italy. At court he was Philip IV's gentleman of the privy chamber. His first wife was his cousin Doña Mencía Fajardo y Zuñiga, and after her death he married Doña Antonia de Mendoza, a lady-in-waiting to Mariana of Austria. He was appointed governor of Estremadura in the war against Portugal.

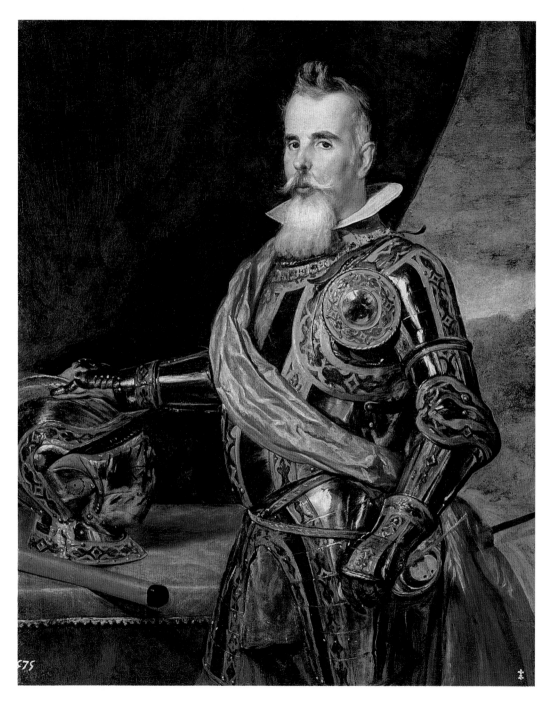

143

Venus at Her Mirror
(The Rokeby Venus)

c. 1650
Oil on canvas, 122.5 × 175 cm
London, The Trustees
of The National Gallery

Many art historians agree that this canvas was painted in Rome during the artist's second trip to Italy between July of 1649 and November of 1650.

Goya's *Maja Desnuda* (Prado, Madrid) and Velázquez's *Venus at Her Mirror* are the only Spanish masterpieces known that depict a naked woman. Nonetheless, according to inventories taken during Velázquez's life, he painted at least two other female nudes, both of which were probably Venuses.

As in works by contemporary Flemish painters, mirrors are important features in Velázquez's paintings. In addition to the superb study of the nude, the artist provides a second element of interest: the face of the model is both real and unreal at the same time (the latter given by the reflection in the mirror), and the mirror only reflects her face either through a sense of reserve or, more probably, for fear of being excommunicated by the Catholic Church.

The modeling of the body has suggested that Velázquez was inspired by ancient sculpture, the Venetian nudes of Tintoretto and Titian, and probably the paintings of Rubens, in particular *Venus's Feast* (Kunsthistorisches Museum, Vienna) which may have been used as a model by the Spanish artist. The blue-grey sheet on which the young woman lies brings out the subtleties of her skin, which, in turn, emphasize the highlights on her sensual, sinuous body painted with exceptional delicacy and sensitivity.

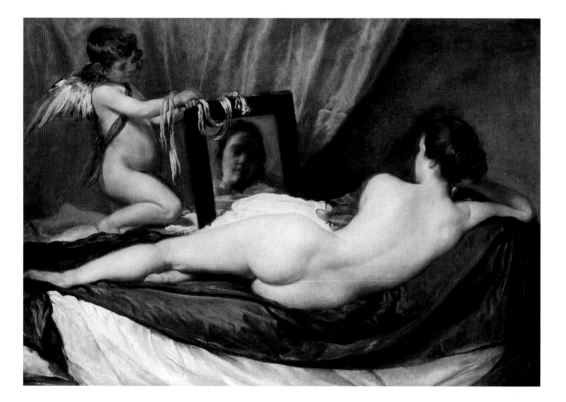

Innocent X

1650
Oil on canvas, 140 × 120 cm
Rome, Galleria Doria
Pamphilij

Pope Innocent X was born in 1576 and died in 1655. Velázquez probably painted the portrait in autumn 1650 during his stay in Rome. It seems that the pope was so pleased with the work ('All too true!' he is supposed to have exclaimed) that he offered the artist a very valuable remuneration which, however, was refused, as Velázquez had traveled to Rome on behalf of his king. Instead he accepted a papal medallion and a gold chain that were even mentioned in a homage after his death.

Comparison of this masterpiece with Titian's *Pope Paul III Farnese with his Nephews Alessandro and Ottavio Farnese* make evident how Velázquez's use of color and delicate touch are similar to the Titianesque painting technique of Venice.

Lionello Venturi wrote that a portrait can be either historic or poetic. This one, however, is both, as Velázquez used his initial visual impression of the pope to give life to a realistically modeled face. In this manner, all the truth and humanity of the subject are fully revealed. It was this technique that brought a breath of fresh air to Spanish portraiture which, before Velázquez, was increasingly sterile and in decline.

In this painting the many reds—one of the most difficult colors to use in painting without either creating loud contrasts or vulgarity—have been graduated and combined in a chromatic harmony that has rarely been equalled. The result is of such splendor, density, richness, and delicacy, in spite of the apparent coarseness of the pope himself, that this painting is without doubt one of the greatest masterpieces of Spanish art.

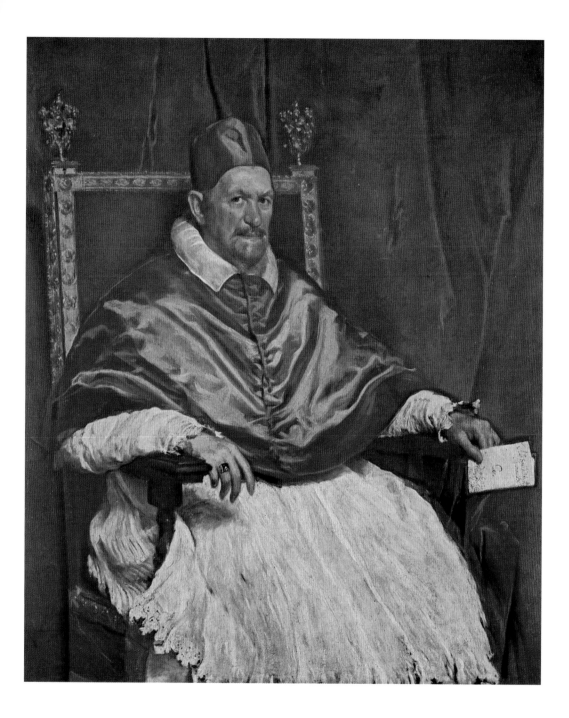

Self-Portrait

c. 1650

Oil on canvas, 45 × 38 cm

Valencia, Museo de Bellas Artes

The artist shows himself in three-quarter profile wearing a starched collar typical of the reign of Philip IV and with his penetrating gaze directed at the observer. His severe expression is emphasized by the prominent mustache and closed mouth.

In this portrait Velázquez is about fifty years of age, as is evidenced by the slight double chin and the lines beneath his eyes. His face is warmly lit and shrouded in an atmosphere that recalls the work of Vermeer. The fluid, well-laden brushstrokes give form to the figure and subtly highlight the luminous areas from those in shadow.

The first mention we have of this self-portrait is by Francisco Pacheco in his treatise *Arte de la pintura,* when he records that during his second stay in Rome Velázquez had painted "a self-portrait that I keep, for the admiration of connoisseurs and for the honor of art." The art critic Camón Aznar underlines that it is "an energy-filled work [painted] with many dry brushstrokes, great precision in the design [...] ." He continues that the figure has a different expression from the self-portrait seen in *Las Meninas,* and that it is a "hard and shadowy painting that has suffered greatly from time and restoration."

The restoration work carried out on the canvas in 1986 in the Prado laboratories has revealed the extraordinary quality of Velázquez's original work, which resulted in an outstanding depth of expression.

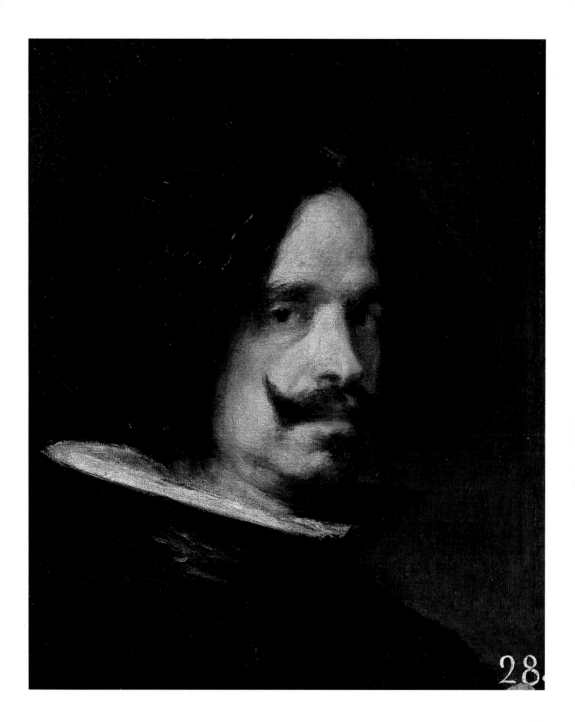

28.

Façade of the Grotto-Loggia, Villa Medici in Rome

c. 1650
Oil on canvas, 44 × 38 cm
Madrid, Museo Nacional
del Prado

Expert opinions on the dating of this small painting and its companion, *Pavillon of Ariadne*, differ greatly. Some critics, including López Rey, think that both were completed in 1630 during the artist's first trip to Italy. Others, like Bardi, propose 1650, the year of Velázquez's second journey. Supporters of the first hypothesis cite a document, referred to by Palomino, that explains that the artist was given permission to reside in Villa Medici while he was in Rome, following a request presented on April 20, 1630 to Secretary of State Cioli, Francesco Niccolini: "S.r Co. di Monterei wished that I accommodated, in the gardens of the Trinità de' Monti, a painter of the King who has come here, and who, I have been told, paints very fine portraits, so that he may stay here all summer."

Bardi notes how in this canvas Velázquez was particularly interested in a Palladian motif (an arch resting on an architrave supported by columns) that was rare in Spain. This piece of architecture can still be seen today perfectly intact and is attributed to Ammannati. The pilasters on either side of the arch crowned by elements similar to Ionic capitals are a typical feature of mannerist architecture. To the right of the niche it is possible to make out a statue of a man.

This work by Velázquez, which undoubtedly heralded the Italian and Provençal landscapes of Fragonard, Hubert Robert, and Corot, is pervaded by a classical realism, and has a unique emotional impact.

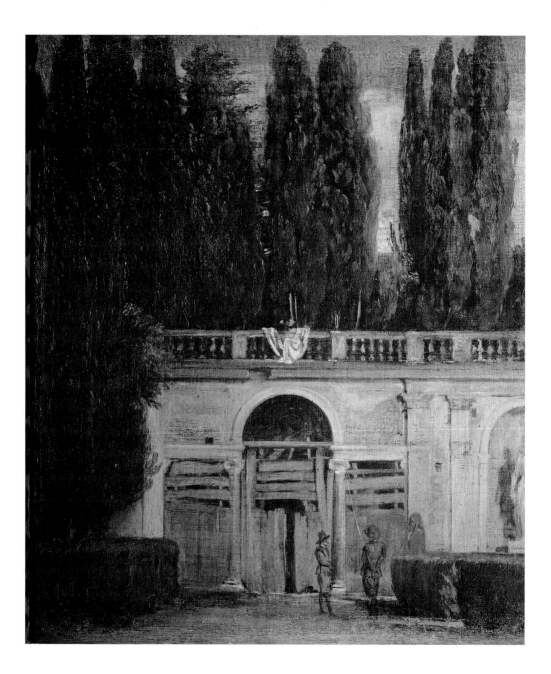

c. 1650
Oil on canvas, 48 × 42 cm
Madrid, Museo Nacional
del Prado

This is the companion piece to the *Façade of the Grotto-Loggia* on the previous page. The pavilion shown was generally known as the Loggia of Cleopatra, but its proper name was given by a statue of Ariadne that at one time stood at the centre of the structure. This was later transported to Florence and substituted by a pair of statues representing Praxiteles' *Aphrodite of Cnidos.*

All the elements in the *Pavillon of Ariadne* are lined by a combination of bands of transparent shadow and vibrantly reflected light: these affect all the architectural details, the features of the landscape and the figures. Velázquez has succeeded in capturing the movement of the patches of light in a surprisingly modern technique that was only seen much later, during the nineteenth century, in works by undisputed masters like Sisley, Pissarro, and Monet. For this reason it can be argued that this painting prefigured impressionism.

Like his contemporaries, Velázquez never painted nature exactly as he saw it. He shared the seventeenth-century's interest in a range of fairly muted colors that the impressionists would later ban from their palettes, preferring the pure and dazzling colors of reflected light. Yet Velázquez equally succeeded in infusing his work with an impression of external life, presaging what Corot and Courbet would only much later produce by drawing directly on nature.

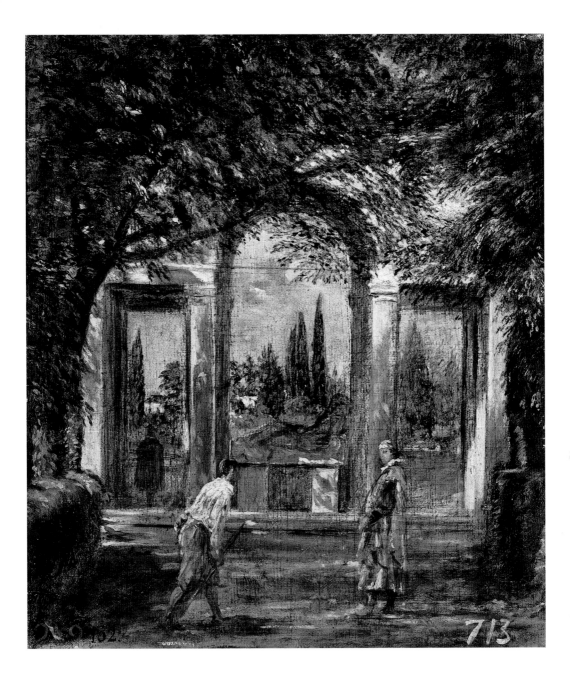

Mariana of Austria

1652–1653
Oil on canvas, 231 × 131 cm
Madrid, Museo Nacional
del Prado

Queen Mariana was the daughter of Emperor Ferdinand III and the Infanta Maria, sister of Philip IV. She was born on December 21, 1634 and died on May 16, 1696. On October 7, 1649, when she was only fifteen years of age, she was married to her uncle, Philip IV, following the death of his first wife, Isabel Bourbon.

According to the majority of art historians, the painting is datable to around 1652 or, at the latest, the early months of 1653. A workshop copy that passed from the palace of Schönbrunn to the Kunsthistorisches Museum in Vienna was sent to Archduke Leopold William on February 23, 1653, therefore the original composition was unquestionably completed before that date. This work shares the same history and location in the Prado as its pendant, *Philip IV* (inv. 1219, Prado) by an unknown artist.

A slightly smaller version (209 × 125 cm) of the portrait of Mariana once belonged to the Alcázar in Madrid before passing to the Prado. As part of an exchange between Spain and France in 1941, this smaller painting has now become the property of the Louvre. Many art critics consider it to be authentic: even Sánchez Cantón believes that the French canvas is the original painted in 1652. However, Allende-Salazar, López Rey, and others consider it a workshop job to which Velázquez may have contributed. Nonetheless, the version in the Prado is the one that is usually considered the original.

The range of colors—blacks, reds, greys, and whites—brightened further by touches of gold, is extremely delicate. The observer's attention is attracted primarily by the red ribbon by the queen's left hand, which brings out the greys and blacks of her dress, while her gold jewellery emphasizes the greys, blacks, and whites of her bodice. The astounding style of this portrait is reminiscent of Renoir.

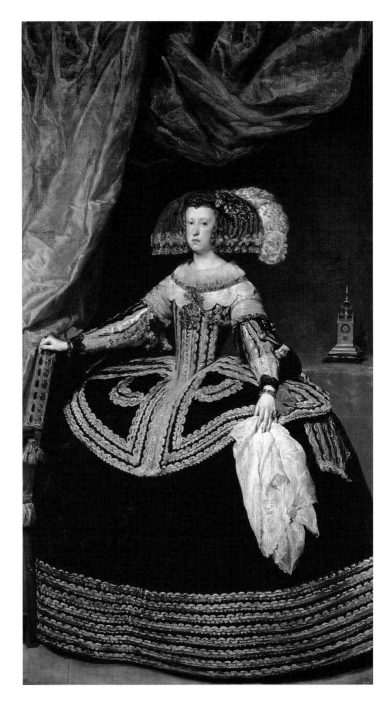

Philip IV

1655
Oil on canvas, 69 × 56 cm
Madrid, Museo Nacional
del Prado

Another version of this portrait exists in London's National Gallery, and some believe it was painted after the Prado version. The difference between the two portraits is that in the Prado painting Philip is dressed in a silky material, whereas in the London one he wears a matt cloth or velvet garment with embroidery on the sleeves and gilded buttons, and the necklace of the Order of the Golden Fleece. In this portrait, the king is shown much more introspective. Dressed in black silk and a simple collar, without the symbols of royalty, Philip is seen only in his moral dimension. According to Pantorba, the two portraits are the only remaining ones of the king that Velázquez actually painted, in other words, both are by Velázquez's hand and neither a copy of the other. His argument for this claim is that in the Prado portrait Philip IV appears two or three years younger than in the London version.

The son of Philip III and Margaret of Austria, Philip IV was born in 1605 and took the throne in 1621. According to Pacheco, Velázquez painted his first portrait of the king in August 1623. This and the London portrait were probably the last to be painted. For a quarter of a century we can follow the marks of time on Philip's features. The later portraits show a certain sadness and tiredness, when political problems in the Iberian peninsula, across Europe, and even in the Indies were increasing. Most certainly Velázquez did not want to show the great disappointments of Philip's reign on his face: the king had to maintain his detachment and indifference to the circumstances which, according to backbiters, merited him the nickname 'Philip the Great' given to him by some courtiers: "as great as a well, and ever greater as more earth [land] is taken away from him." This helps to explain the rather absent and distant expression seen on the king's face in Velázquez's last portraits of him, though the artist was always respectful and sincere towards his sovereign.

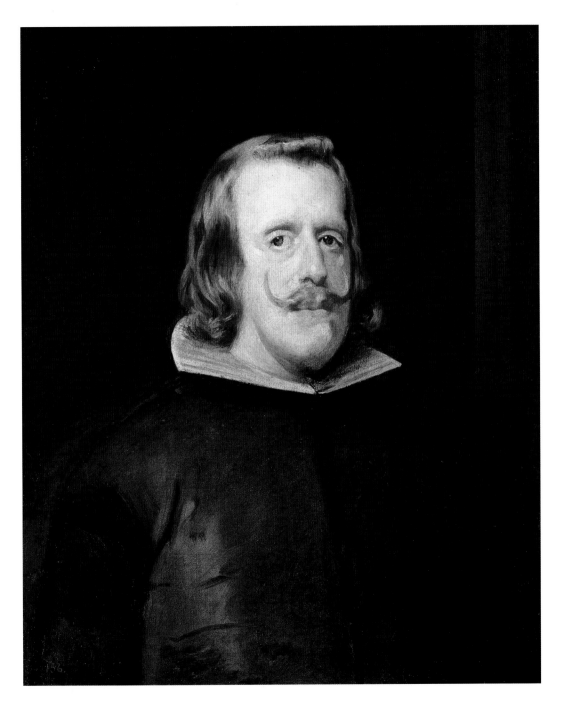

The Infanta Margarita

1655
Oil on canvas, 115 × 91 cm
Madrid, Fundación Casa
de Alba

The Infanta Margarita was the daughter of Philip IV and Queen Mariana. Born on July 12, 1651, she married Emperor Leopold of Germany on December 12, 1666 and died on March 12, 1673. It is generally thought that the painting was the first of Velázquez's various portraits of the Infanta and that she may have been about three years of age at the time.

The artist managed to enter into the fragile personalities of his young models and to transpose onto canvas their embarrassment, shyness, and even a certain degree of joyfulness, the mood which certainly would have become apparent as soon as the sitting ended. Velázquez rendered all this in spite of the rigorous formality of the Spanish court, in accordance with which the tiny princes and princesses had to be bound in rigid farthingales and dressed up in magnificent clothes. Velázquez's great ability lay in portraying an expression that flickered across a face for an instant or a furtive glance that revealed the sitter's real character, and not one held during a long sitting.

The vibrant pictorial quality of the brushstrokes, the way in which the paint was applied, and the slightly shaded reflections of the light are all reminiscent of Renoir's portraits of children.

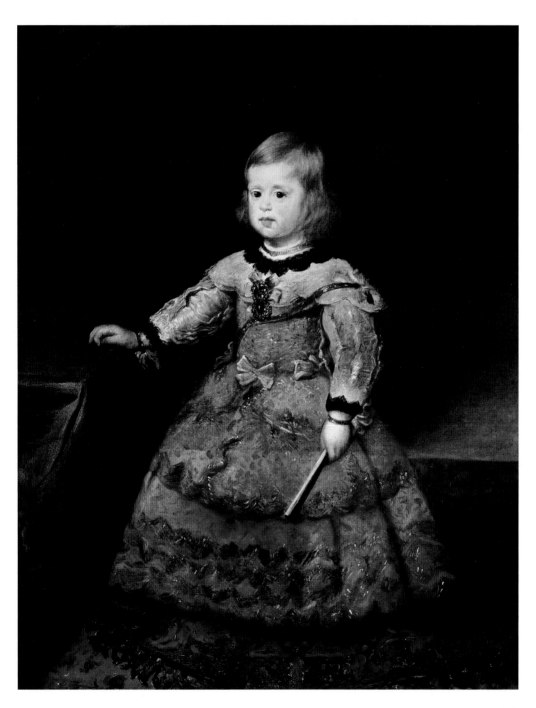

Las Meninas
(Velázquez and the Royal Family)

1656

Oil on canvas, 318 × 276 cm
Madrid, Museo Nacional
del Prado

The painting was executed in 1656 and is universally recognized as Velázquez's masterpiece. In 1666 it was inventoried as *El Cuadro de la Familia* ('The Painting of the Family'). Its current name, *Las Meninas*, dates from the nineteenth century: the word *menina* is of Portuguese origin and means maid-of-honor. The painting shows Velázquez himself as he paints. At the centre stands the Infanta Margarita with Doña María Augustina de Sarmiento to her right and Doña Isabel de Velasco to her left, both of whom were the Infanta's maids of honor. There are also the dwarfs Mari-Bárbola and Nicolasito Pertusato on the right of the picture, the latter prodding at the dog with his foot. Behind the main figures and on the right are a couple standing: Doña Marcela de Ulloa, an attendant to the queen's ladies-in-waiting, and, it is presumed, don Diego Ruíz de Azcona, who cannot be identified with certainty due to the shadow he stands in. Standing in the doorway at the back of the picture is don José Nieto Velázquez, the palace marshall and perhaps a relative of the painter. In the mirror at the back of the room we see the reflections of the queen, Mariana of Austria, and the king, Philip IV, whom we presume are posing in front of Velázquez's easel. The two paintings above the mirror show mythological scenes copied by Mazo from a work by Rubens (*Pallas and Arachne*) and another by Jacob Jordaens (*Apollo and Pan*). Each figure in the carefully studied group has a precise position in keeping with the rigid customs of the Spanish court of the time. The role of the artist, who has painted his own face clearly on the left of the picture, is only secondary in the painting. He has succeeded in infusing the internal scene with his own realism and thus the painting becomes much more than just a photographic document of life. From the time of this painting, Velázquez's technique remained unsurpassed: he demonstrated the power that an artist is able to exercise on the visible world and the supremacy that art has over reality.

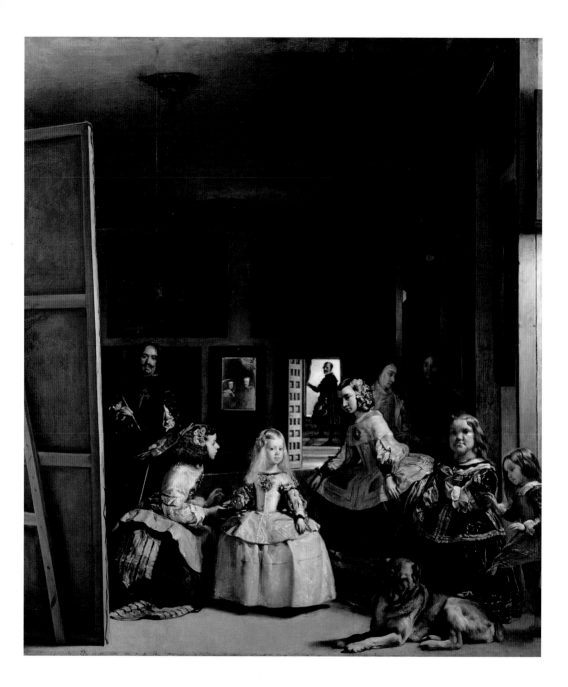

Las Hilanderas
(The Fable of Arachne)

c. 1657

Oil on canvas, 167 × 252 cm
Madrid, Museo Nacional
del Prado

Most art historians ascribe *Las Hilanderas* to circa 1657 due to the clearly apparent influences and style of the Italian school. Others, like López Rey, prefer to date it to between 1644 and 1650.

Until the mid-twentieth century the painting was known either as *The Tapestry Weavers of Santa Isabella in Madrid* or *The Spinners*, but in 1948 Diego Angulo Iñiguez called attention to the similarity between the scene and the myth of Arachne (the 1664 inventory refers to *The Fable of Arachne*). In the legend, Pallas Athena, goddess of the arts, weaving, and spinning, was challenged to weave a tapestry by a girl from Lydia named Arachne, and lost the competition. Enraged by the affront to her dignity, the goddess (who was disguised as an old woman) tore Arachne's tapestry to pieces, which illustrated the loves of the gods (the first episode showed the rape of Europa). In desperation, Arachne hung herself, but Athena brought her back to life and turned her into a spider.

According to Charles de Tolnay and Angulo Iñiguez, the spinners at work in Velázquez's painting show the characters in the legend. The young woman on the right would be Arachne and the old woman on the left Athena before revealing her true identity. In the background of the painting, using the technique of simultaneous episodes, the second part of the legend is taking place: standing before Arachne's tapestry of the rape of Europa is Athena wearing a helmet and sumptuous clothes. The scene is set in a small and slightly higher room that appears rather like a stage.

The patches of color applied using small, rapid brushstrokes —typical of other works by Velázquez—testify to his prodigious technical skills and herald impressionism and the pointillist technique.

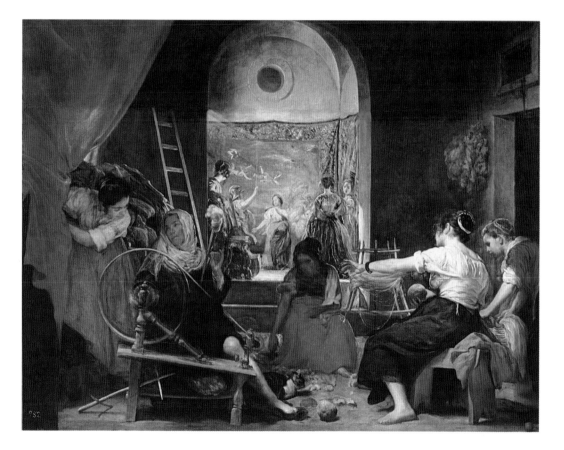

Prince Felipe Próspero

1659
Oil on canvas, 128.5 × 99.5 cm
Vienna, Kunsthistorisches
Museum

The Infante, Felipe Próspero, son of Philip IV and Mariana, was congenitally ill and died very young, at the age of four. Despite the prince's rigid pose, the portrait had no official character. His clothes are much less sumptuous than the formal costumes worn by Prince Baltasar Carlos or the Infanta Margarita. Felipe wears a pink dress with silver decorations and a gauzy overdress on which are hung various pendants: amulets to ward off the evil eye and a pomander to protect the prince against infections.

The tired face of the blue-eyed prince is made even paler by the silver highlights in his straw-blond hair. A weak light enters the room through a doorway behind the prince to limit the threatening darkness in which the scene is set. Palomino considered it one of Velázquez's best portraits, in particular praising the little dog on the seat. The way in which the dog is rendered suggests that it is the prince's friend or play mate.

With regard to his palette of colors, Velázquez, who was by now at the end of his artistic career, created a marvellous symphony of reds that range from the palest to darkest tones. The whites on the prince's bodice, apron, and cuffs seem almost radiant and are completely integrated into the composition of the scene. The brushstrokes that create the carpet once more bear witness to the originality of the artist's vision and his pre-impressionist tendencies.

This is the first painting in which Velázquez expresses a strong sense of sadness, almost as though he was stating that soon he would no longer be able to paint kings or queens, dwarfs or jesters, popes or saints, nor even the common people—all figures from his corpus that he had depicted with the same sensibility and profundity.

1659
Oil on canvas, 83 × 248 cm
Madrid, Museo Nacional
del Prado

According to legend, Argus, a prince from a city in Peloponnesia, had one hundred eyes, half of which were always open. Juno ordered him to watch over the young woman Io, who had been seduced by her husband Jupiter and turned into a heifer. Jupiter ordered Mercury to send Argus to sleep with the sound of his flute, strike him with a stone, and cut off his head. Juno then took Argus's eyes and placed them on the tail of the peacock, which became her symbol.

Velázquez turned this legend into a realistic scene so infused with truthfulness that it appears more like an illustration from a picaresque novel than an ancient myth. The painting transports the observer into the world of Cervantes' *Don Quixote* and *Novelas ejemplares*.

Some scholars consider the depiction of Argus's legs to resemble that of the *Dying Gaul* seen by the artist in Rome, while the rest of the figure, according to others, was inspired by the *Bronze Nude* above the spandrel of Hezekiah in the Sistine Chapel.

The lightness with which the work was painted, especially the rendering of the light flowing from behind, and the marvelous use of chiaroscuro underline the painting's realism and imbue it with an elegiac beauty.

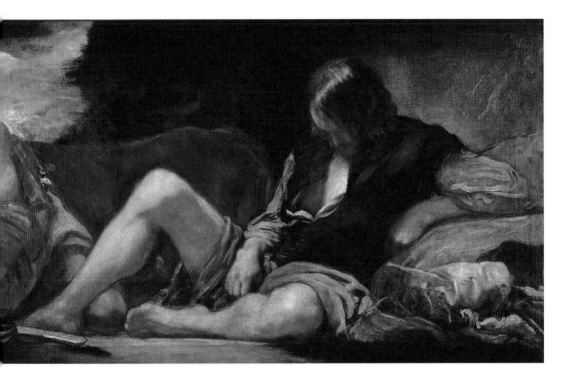

c. 1660
Oil on canvas, 212 × 147 cm
Madrid, Museo Nacional
del Prado

Despite being at the end of his artistic life, Velázquez continued to paint beautiful portraits of the royal family in which he further developed his technique. These were the years of portraits of the young princes and princesses that gave the painter the opportunity to combine the delicacy of their infant grace with the streak of melancholy sometimes found in children. This painting, which Velázquez was unable to finish and was later completed by his disciple and son-in-law Juan Bautista Mazo, was his last work.

The hands and head of the girl may be attributed by Mazo, but in particular the face is not Velázquez's. As Pantorba rightly commented, it was painted "with a poor and tired technique." Not even the curtain in the background is worthy of the master. In contrast, nothing surpasses the magnificence of the Infanta's clothes: the dress, which is described by the Prado catalogue as a "*carignana* bonnet, bodice separate from the large skirt, pink farthingale with silver thread," is of an incomparable beauty and elegance. When viewed close up, the reflections of light on the enormous pink and silver farthingale are of a poetic truthfulness. Another outstanding feature is the large handkerchief that hangs from the princess's right hand, while her left holds a small bouquet of roses and violets.

The Infanta Margarita, daughter of Philip IV and Mariana of Austria (Philip's second wife from 1649), was born in July 1651, and all her portraits by Velázquez must have been painted before his death in 1660.

A half-length replica of this painting exists, possibly by Mazo, in which the Infanta wears a brooch on her chest in the form of the two-headed eagle of the Austrian empire. Velázquez's disciple portrayed the Infanta in mourning for her father in 1666, the same year that she wed. Margarita died in 1673 in Vienna and was buried in the imperial Capuchin Crypt.

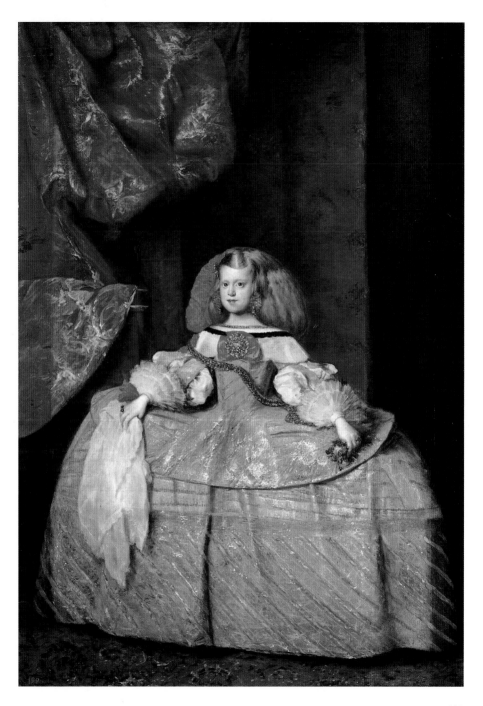

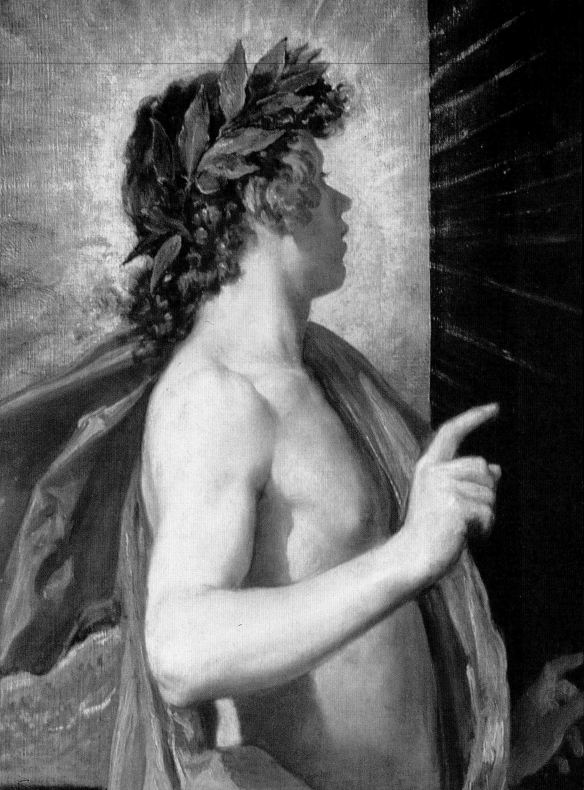

Appendix

Chronological Table

	The Life of Velázquez	Historical and Artistic Events
1599	Baptized Diego Rodriguez da Silva y Velázquez; the family is of Portuguese origin.	The Spanish fleet attempts to invade England but is routed.
1609	Enters the workshop of Francisco de Herrera the Elder, where he remains for a few months.	Known as the Twelve Year Truce, a period of peace begins during the Eighty Years War (1568–1648) between the rebel provinces of the Low Countries and Spain. Clashes occur in the Low Countries between Remonstrants and Counter-Remonstrants on theological questions.
1610	Switches workshop to be under the artistic guidance of Francisco Pacheco.	Caravaggio dies at Porto Ercole, Italy.
1618	Marries Juana, Pacheco's daughter.	During the Synod of Dordrecht the Remonstrants are expelled from the Church. Prince Maurice sides with the Counter-Remonstrants.
1619	His first daughter, Francisca, is baptized.	
1621	His second daughter, Ignacia, is baptized.	The Twelve Year Truce comes to an end. With the death of Philip III, his son Philip IV ascends the Spanish throne. Gaspar de Olivares is the Spanish prime minister.
1628	Meets Rubens who is visiting Madrid for the second time. The king assigns Velázquez a daily pension.	The Huguenots of La Rochelle are massacred. Emperor Ferdinand II issues the Edict of Restitution which obliges Protestant princes to restore all Church lands obtained since 1555.
1629	Philip IV allows Velázquez to make a trip to Italy: on his arrival in Genoa, he travels to Milan, Venice, Ferrara, Bologna and Rome. He returns to Madrid two years later.	Under Richelieu the French invade Piedmont. Charles I of England dissolves Parliament and governs alone.
1638	In autumn the duke of Modena, Francesco I, visits Madrid and Velázquez begins his portrait.	The queen of France, Marie de' Medici, arrives in Antwerp in September. The Flemish painter Pieter Brueghel the Younger dies in Antwerp.
1640	Philip assigns Velázquez an advance payment of 500 ducats a year for the works he will paint.	The painter Pieter Paul Rubens dies in Antwerp.

The Life of Velázquez	Historical and Artistic Events
1642 In spring he accompanies the king to Aragon for a few months.	Cardinal Richelieu dies in France and is replaced as prime minister by Jules Mazarin. Galileo Galilei dies in Arcetri. Guido Reni dies in Bologna. The Dutch navigator Abel Tasman discovers Tasmania, the Tonga Islands and New Zealand.
1647 Appointed inspector of the palace's Octagonal Room.	The Dutch historian Pieter Corneliszoon Hooft dies. Masaniello revolts in Naples against the Spanish viceroy..
1649 Velázquez is in Italy; in Venice he admires works by Tintoretto and Veronese, then moves on to Modena, Parma and Bologna to see works by Correggio. In July he is in Rome, where he paints the portrait of Pope Innocent X.	Charles II of England beheaded and a republic proclaimed.
1650	In summer William II besieges Amsterdam but dies in November. In France the Fronde of the Princes, formed by nobles aligned with the prince of Condé, allies itself with Spain and forces the court of Cardinal Mazarin to withdraw from Paris.
1653 Philip IV sends a portrait by Velázquez of the Infanta Maria Teresa to the imperial court in Vienna.	Oliver Cromwell installs a dictatorship in England.
1656 Paints *Las Meninas* and superintends the hanging of the paintings and other works in El Escorial.	Dutch painter Gerrit van Horthorst, called Gherardo della Notte, dies. Pascal publishes *Lettres provinciales*.
1657	France and England under Cromwell ally against Spain. Lorenzo Bernini begins construction of the colonnade around Piazza San Pietro in the Vatican and is commissioned to design the Scala Regia. The disciples of Galileo Galilei found the Accademia del Cimento in Florence.
1660 In April he goes to Fuenterrabia to organize the royal residence for the ceremonial handing over of the Infanta Maria Teresa to her future husband Louis XIV of France. He falls ill and dies on 6 August.	The English Parliament invites Charles Stuart to return to England where he is crowned Charles II. One of the most important scientific academies in Europe, the Royal Society, is founded in London. In Seville the Spanish painter Bartolomé Murillo founds the Academia de Bellas Artes.

Geographical Locations of the Paintings

in public collections

Italy		*Portrait* Oil on canvas, 67 x 50 cm Rome, Musei Capitolini 1630		*Innocent X* Oil on canvas, 140 x 120 cm Rome, Galleria Doria Pamphilij 1650
Austria		*Queen Isabel* *di Spagna* Oil on canvas, 128.5 x 99.5 cm Vienna, Kunsthistorisches Museum *c.* 1632		*Prince Felipe Próspero* Oil on canvas, 128.5 x 99.5 cm Vienna, Kunsthistorisches Museum 1659
France		*Democritus* Oil on canvas, 98 x 81 cm Rouen, Musée des Beaux-Arts 1624 (or 1640)		
Great Britain		*Old Woman Frying Eggs,* Oil on canvas, 100.5 x 119.5 cm Edinburgh, National Gallery of Scotland *c.* 1618		*Kitchen Scene with Christ* *in the House of Martha* *and Mary* Oil on canvas, 60 x 103.5 cm London, The Trustees of The National Gallery *c.*1620
		The Water-Seller in Seville Oil on canvas, 105 x 80 cm London, Wellington Museum (Apsley House), The Board of Trustees of The Victoria and Albert Museum 1620		*Venus at Her Mirror* *(The Rokeby Venus)* Oil on canvas, 122.5 x 175 cm London, The Trustees of The National Gallery *c.* 1650

Russia	Three Men at Table Oil on canvas, 108 x 102 cm St Petersburg, The State Hermitage Museum *c.* 1617	The Count-Duke of Olivares Oil on canvas, 67 X 54,5 cm St Petersburg, The State Hermitage Museum 1635
Spain	The Adoration of the Magi Oil on canvas, 203 x 125 cm Madrid, Museo Nacional del Prado 1619	Portrait of a Man with a Goatee (Francisco Pacheco?) Oil on canvas, 40 x 36 cm Madrid, Museo Nacional del Prado 1620
	A Young Man (Self-Portrait?) Oil on canvas, 56 x 39 cm Madrid, Museo Nacional del Prado 1623	Philip IV in Armour Oil on canvas, 201 x 102 cm Madrid, Museo Nacional del Prado *c.* 1624
	Triumph of Bacchus (The Topers) Oil on canvas, 165.5 x 227.5 cm Madrid, Museo Nacional del Prado 1628-1629	Joseph's Bloody Coat Brought to Jacob Oil on canvas, 223 x 250 cm El Escorial (Madrid), Monasterio de San Lorenzo 1630
	The Forge of Vulcan Oil on canvas, 223 x 290 cm Madrid, Museo Nacional del Prado 1630	Christ in a Landscape Oil on canvas, 100 x 57 cm Madrid, Museo Nacional del Prado 1631

Spain

Christ on the Cross
Oil on canvas,
248 x 169 cm
Madrid, Museo Nacional
del Prado
c. 1631

The Jester,
Pablo de Valladolid
Oil on canvas,
209 x 123 cm
Madrid, Museo Nacional
del Prado
1632-1633

The Jester
'Don Juan de Austria'
Oil on canvas,
210 x 123 cm
Madrid, Museo Nacional
del Prado
1632-1633

The Count-Duke
of Olivares on Horseback
Oil on canvas,
313 x 239 cm
Madrid, Museo Nacional
del Prado
1634

Philip IV as a Huntsman
Oil on canvas,
191 x 126 cm
Madrid, Museo Nacional
del Prado
1634-1635

The Surrender of Breda
(Las Lanzas)
Oil on canvas,
307 x 367 cm
Madrid, Museo Nacional
del Prado
1634-1635

Saint Anthony Abbot
and Saint Paul the Hermit
Oil on canvas,
257 x 188 cm
Madrid, Museo Nacional
del Prado
1634-1660

Prince Baltasar Carlos
on Horseback
Oil on canvas,
209 x 173 cm
Madrid, Museo Nacional
del Prado
c. 1635

The Sculptor
(Juan Martínez Montañés?)
Oil on canvas,
109 X 107 cm
Madrid, Museo Nacional
del Prado
1635-1636

The Dwarf Juan Calabazas
(Calabacillas)
Oil on canvas, 106 X 83 cm
Madrid, Museo Nacional
del Prado
1638-1639

Spain

Menippus
Oil on canvas, 179 X 94 cm
Madrid, Museo Nacional
del Prado
1639-1642

Aesop
Oil on canvas, 179 x 94 cm
Madrid, Museo Nacional
del Prado
1639-1642

Mars
Oil on canvas, 179 x 95 cm
Madrid, Museo Nacional
del Prado
1640

Court dwarf
Don Antonio el inglés
Oil on canvas,
142 x 107 cm
Madrid, Museo Nacional
del Prado
1640-1645

The Coronation
of the Virgin
Olio su tavola,
176 x 134 cm
Madrid, Museo Nacional
del Prado
c. 1641-1644

The dwarf
Francisco Lezcano,
called 'el niño de Vallecas'
Oil on canvas, 107 x 83 cm
Madrid, Museo Nacional
del Prado
1642

Don Diego de Acedo,
el Primo
Oil on canvas, 107 x 82 cm
Madrid, Museo Nacional
del Prado
1644

The Dwarf
Sebastián de Morra
Oil on canvas, 106 x 81 cm
Madrid, Museo Nacional
del Prado
c. 1644

Juan Francisco
de Pimentel, Count
of Benavente
Oil on canvas, 109 x 88 cm
Madrid, Museo Nacional
del Prado
1648

Façade of the Grotto-Loggia,
Villa Medici in Rome
Oil on canvas, 48 x 42 cm
Madrid, Museo Nacional
del Prado
c. 1650

Spain

Pavillon of Ariadne,
Villa Medici in Rome
Oil on canvas, 44 x 38 cm
Madrid, Museo Nacional
del Prado
c. 1650

Mariana of Austria
Oil on canvas,
231 x 131 cm
Madrid, Museo Nacional
del Prado
1652-1653

Philip IV
Oil on canvas, 69 x 56 cm
Madrid, Museo Nacional
del Prado
1655

The Infanta Margarita
Oil on canvas, 115 x 91 cm
Madrid, Fundación Casa
de Alba
1655

Las Meninas (Velazquez
and the Royal Family)
Oil on canvas,
318 x 276 cm
Madrid, Museo Nacional
del Prado
1656

Las Hilanderas
(The Fable of Arachne)
Oil on canvas, 167 x 252
cm
Madrid, Museo Nacional
del Prado
c. 1657

Mercury and Argus
Oil on canvas, 83 x 248 cm
Madrid, Museo Nacional
del Prado
1659

The Infanta
Doña Margarita of Austria
Oil on canvas,
212 x 147 cm
Madrid, Museo Nacional
del Prado
c. 1660

The Temptation of Saint
Thomas Aquinas
Oil on canvas, 244 x 203 cm
Orihuela, Museo Diocesano
de Arte Sacra
1631

Saint Idelfonso receiving
the Chasuble from the Virgin
Oil on canvas, 166 x 120 cm
Seville, Museo de Bellas
Artes
1623

Spain

Self-Portrait
Oil on canvas,
45 x 38 cm
Valencia, Museo de Bellas
Artes
c. 1650

THE PAINTERS' PAINTER

Why is Velásquez the painters' painter? Why has he such a profound and abiding influence upon so many modern artists? In part because he is the hierophant of that new knowledge which proclaims that it is worthier to paint perfectly what they eye has seen than the vision that the aspiring heart conceives. The Italians strove to realize in paint the invisible dogmas of the Church, and a few, because they were men of genius, produced masterpieces. Velásquez, and some of the Dutchmen, painted life, and because they represented the colours of objects modified by the action of light, air, and distance, they produced masterpieces.

Years later, when "values came upon France like a religion," Manet uttered that great saying, "Light is the principle person in a picture." With all—with Holman Hunt, blind to values, as with Velásquez, seeing them constantly—it is the personality and craftsmanship of the artists, not the mysticism of the subject, that moves, delights, and stimulates us. When painting in France began to be considered scientifically, it was to Velásquez that the eyes of the pioneers of the modern movement turned. He was an example not only of great achievement but also of achievement that was reached slowly and grasped firmly. Examine his pictures chronologically, beginning with his dark, early manner, before he learnt that space can be decorated by the use of tone as well as by figures, the days when he painted the crowded and piecemeal "Topers" and "The Forge of Vulcan"; and you realize how gradual was the education of his eye and hand. Study his religious and mythological pictures, such as "The Adoration of the Kings," "The Coronation of the Virgin," and 'Mars' at the Prado Museum; and you realize that even Diego Velásquez, when he was not painting a subject that he had seen and felt, was as other men. His imagination was not the equal of his eye.

He was no child prodigy. He began with the simplest themes, some *bodegone* or "kitchen piece" that he had seen in his father's house, or in the streets of Seville—an old woman cooking eggs, two young men at a meal, a water-carrier—painting them with searching but simple realism, learning to appreciate (his eyes, not books

or masters, were his teachers) the lights and shades of the tones under the influence of distance and atmosphere. This knowledge grew, and reached its culmination in "The Maids of Honour," where the beholder is persuaded that, by some enchantment, depth has been persuaded to visit a flat, upright surface.

It must not be forgotten that a Master sometimes intentionally breaks the law. Velásquez lowered the backgrounds of his equestrian portraits, so that they should not be higher in value than the figures upon which he wished the eyes of the spectator to focus. The great draughtsman is born with the powers of a great draughtsman implicit intellectually in him. The fine colourist is born with the sense of colour implicit emotionally in him. A great seer of true values like Velásquez is cradled with the sense of them in his vision, a sense that is perfected only by unremitting labour.

"Painted by pure will" was the comment of Mengs on "The Maids of Honour." Fifteen years later he wrote to Antonio Ponz: "The best models of the natural style are the works of Diego Velásquez, in their knowledge of light and shade, in the play of aerial effect, which are the most important features of this style, because they give a reflection of the truth."

Strange is the effect of Velásquez upon the painter! "The Topers" is one of Velásquez's early pictures.... Probably painted in his thirtieth year, under the influence of the exuberant talk and encouragement of Rubens, although ungainly in composition, and not executed as if Velásquez had seen the subject as a whole, it has such a sheer technical accomplishment, the observation of character and tone is so superb that [Sir David] Wilkie may well have spent hours before it trying to pierce into the secret of the Spaniard's power and method; and "at last, wearied with contemplation, rise with a sigh of despair." Goya, who, when he found he could not make enough by painting, performed in the bull-ring, valued "The Topers" in 1780 at 40,000 reals—about £416, a large sum in those days.

Slowly, silently, and surely he advanced into the position of the painters' painter. Leighton, always learning, devoted one of his last Discourses to Velásquez; and I remember the eager, absorbed attention of Browning, who for an hour and more sat motionless in the corner seat of the front bench, maybe meditating a poem, perhaps a dramatic monologue on that scene in Rome during Velásquez's second Italian journey in 1650, when the Romand gathered in the cloisters of the Pantheon to see the portrait Velásquez had painted of his servant and colour-grinder, Juan de Pareja, and the painters who were present declared "that all else, whether old or new, was painting; this picture alone was truth."

*E*xtracts from Sir William Stirling-Maxwell's Annals of the Artists of Spain (Vol. 2).

He was the friend of Rubens, the most generous, and of Ribera, the most jealous, of the bretheren of his craft; and he was the friend and protector of Cano and Murillo, who, next to himself, were the greatest painters of Spain. Carreño de Miranda, the ablest of the court painters whom he left behind, owed his introduction to the King's service to the good nature of Velázquez. Elected one of the alcaldes of Madrid, his time would have been inconveniently occupied by municipal duties, had not Velázquez obtained him exemption from them by procuring him employment in the Alcazar, where his talents soon attracted the favourable notice of the King. The example and personal influence of Velázquez doubtless tended very greatly to the preservation of that harmony which prevailed amongst the artists of Madrid in this reign, and which presents so pleasing a contrast to the savage discord in the schools of Rome and Naples, where men contended with their rivals, not merely with the pencil, but with the cudgel, the dagger, and the drug. The favourite of Philip IV, in fact, his minister for artistic affairs, he filled this position with a purity and a disinterestedness very uncommon in the councils of state; he was the wise and munificent distributor, and not, as too many men would have been, the greedy monopolist, of royal bounties; and to befriend an artist less fortunate than himself was one of the last acts of his amiable and glorious life.

Velázquez, it must be owned, rarely attempted the loftiest flights. Of his few religious subjects, some are purposely treated as scenes of everyday life; as, for

example, "Joseph's Coat," and the "Adoration of the Shepherds," and that still earlier work, the powerful "St. John Baptist," formerly in the collection of Mr. Williams at Seville, and more lately in the Standish gallery of the Louvre. In the "Christ at Emmaus," a work of great power, the two disciples seated at table with Our Lord are a pair of peasants who may be recognised in the drunken circle surrounding Bacchus in the "*Borrachos.*" Once, indeed, he has significantly failed in reaching the height to which he aspired, in the unfortunate Apollo of the "Forge of Vulcan." But the "Crucifixion" of the nunnery of San Placido shows how capable he was of dealing with a great and solemn subject, and what his works would have been had it been his vocation to paint the saints of the calendar instead of the sinners of the Court. Of the religious pictures of his early days, when he lived amongst the churchmen of Seville, several are destroyed or forgotten; such as the "Virgin of the Conception," and 'St. John writing the Apocalypse," painted for the Carmelites of his native city; "Job and his comforters sittings amongst the Ashes," once in the Chartreuse of Xeres; and the "Nativity of our Lord," which perished by fire in 1832, with the Chapter-house of Plasencia.

He was almost the only Spanish artist that ever attempted to delineate the naked charms of Venus. Strong in interest at Court, and with the Holy Office, he ventured upon this forbidden ground at the desire of the Duke of Alba, and painted a beautiful picture of the Queen of Love, reclining with her back turned, and her face reflected in a mirror, as a companion-piece to a Venus in a different attitude of repose, by Titian.

From Quevedo's poem El Piacel, *in* Obras (Vol. 9)

By thee! Our own Velázquez, great
In genius as in plastic skill,
Sweet beauty's self can recreate,
And lend significance at will
To things that distant are and dead,
With realising touch and hue,
Till mimic canvas featly spread,
Non semblance seems, but nature true;

Till forth each shape by figure stands
In warm and round and ripe effect,
And eyes first ask the aid of hands
The fine illusion to detect,
Then deem the picture,—by the skill
That few shall reach and none surpass,
Delighted and deluded still,—
The face of nature in a glass.

An excerpt from Michel Foucault's The Order of Things. Copyright © 1966 by Editions Gallimard. Reprinted by permission of Georges Borchardt, Inc., for Editions Gallimard.

LAS MENINAS

I

The painter is standing a little back from his canvas. He is glancing at his model; perhaps he is considering whether to add some finishing touch, though it is also possible that the first stroke has not yet been made. The arm holding the brush is bent to the left, towards the palette; it is motionless, for an instant, between canvas and paints. The skilled hand is suspended in mid-air, arrested in rapt attention on the painter's gaze; and the gaze, in return, waits upon the arrested gesture. Between the fine point of the brush and the steely gaze, the scene is about to yield up its volume.

But not without a subtle system of feints. By standing back a little, the painter has placed himself to one side of the painting on which he is working. That is, for the spectator at present observing him, he is to the right of his canvas, while the latter, the canvas, takes up the whole of the extreme left. And the canvas has its back turned to that spectator: he can see nothing of it but the reverse side, together with the huge frame on which it is stretched. The painter, on the other hand, is perfectly visible in his full height; or at any rate, he is not masked by the tall canvas which may soon absorb him, when, taking a step towards it again, he returns to his task; he has no doubt just appeared, at this very instant, before the eyes of the spectator,

emerging from what is virtually a sort of vast cage projected backwards by the surface he is painting. Now he can be seen, caught in a moment of stillness, at the neutral centre of this oscillation. His dark torso and bright face are half-way between the visible and the invisible: emerging from that canvas beyond our view, he moves into our gaze; but when, in a moment, he makes a step to the right, removing himself from our gaze, he will be standing exactly in front of the canvas he is painting; he will enter that region where his painting, neglected for an instant, will, for him, become visible once more, free of shadow and free of reticence. As though the painter could not at the same time be seen on the picture where he is represented and also see that upon which he is representing something. He rules at the threshold of those two incompatible visibilities.

The painter is looking, his face turned slightly and his head leaning towards one shoulder. He is staring at a point to which, even though it is invisible, we, the spectators, can easily assign an object, since it is we, ourselves, who are that point: our bodies, our faces, our eyes. The spectacle he is observing is thus doubly invisible: first, because it is not represented within the space of the painting, and, second, because it is situated precisely in that blind point, in that essential hiding-place into which our gaze disappears from ourselves at the moment of our actual looking. And yet, how could we fail to see that invisibility, there in front of our eyes, since it has its own perceptible equivalent, its sealed-in figure, in the painting itself? We could, in effect, guess what it is the painter is looking at if it were possible for us to glance for a moment at the canvas he is working on; but all we can see of that canvas is its texture, the horizontal and vertical bars of the stretcher, and the obliquely rising foot of the easel. The tall, monotonous rectangle occupying the whole left portion of the real picture, and representing the back of the canvas within the picture, reconstitutes in the form of a surface the invisibility in depth of what the artist is observing: that space in which we are, and which we are. From the eyes of the painter to what he is observing there runs a compelling line that we, the onlookers, have no power of evading: it runs through the real picture and

emerges from its surface to join the place from which we see the painter observing us; this dotted line reaches out to us ineluctably, and links us to the representation of the picture.

In appearance, this locus is a simple one; a matter of pure reciprocity: we are looking at a picture in which the painter is in turn looking out at us. A mere confrontation, eye's catching one another's glance, direct looks superimposing themselves upon one another as they cross. And yet this slender line of reciprocal visibility embraces a whole complex network of uncertainties, exchanges, and feints. The painter is turning his eyes towards us only in so far as we happen to occupy the same position as his subject. We, the spectators, are an additional factor. Though greeted by that gaze, we are also dismissed by it, replaced by that which was always there before we were: the model itself. But, inversely, the painter's gaze, addressed to the void confronting him outside the picture, accepts as many models as there are spectators; in this precise but neutral place, the observer and the observed take part in a ceaseless exchange. No gaze is stable, or rather, in the neutral furrow of the gaze piercing at a right angle through the canvas, subject and object, the spectator and the model, reverse their roles to infinity. And here the great canvas with its back to us on the extreme left of the picture exercise its second function: stubbornly invisible, it prevents the relation of these gazes from ever being discoverable or definitely established. The opaque fixity that it establishes on one side renders forever unstable the play of metamorphoses established in the centre between spectator and model. Because we can see only that reverse side, we do not know who we are, or what we are doing. Seen or seeing? The painter is observing a place which, from moment to moment, never ceases to change its content, its form, its face, its identity. But the attentive immobility of his eyes refers us back to another direction which they have often followed already, and which soon, there can be no doubt, they will take again: that of the motionless canvas upon which is being traced, has already been traced perhaps, for a long time and forever, a portrait that will never again be erased. So that the painter's sovereign gaze commands a virtual triangle whose outline defines this pic-

ture of a picture: at the top—the only visible corner—the painter's eyes; at one of the base angles, the invisible place occupied by the model; at the other base angle, the figure probably sketched out on the invisible surface of the canvas.

As soon as they place the spectator in the field of their gaze, the painter's eyes seize hold of him, force him to enter the picture, assign him a place at once privileged and inescapable, levy their luminous and visible tribute from him, and project it upon the inaccessible surface of the canvas within the picture. He sees his invisibility made visible to the painter and transposed into an image forever invisible to himself. A shock that is augmented and made more inevitable still by a marginal trap. At the extreme right, the picture is lit by a window represented in very sharp perspective; so sharp that we can see scarcely more than the embrasure; so that the flood of light streaming through it bathes at the same time, and with equal generosity, two neighbouring spaces, overlapping but irreducible: the surface of the painting, together with the volume it represents (which is to say, the painter's studio, or the salon in which his easel is now set up), and, in front of that surface, the real volume occupied by the spectator (or again, the unreal sight of the model). And as it passes through the room from right to left, this vast flood of golden light carries both the spectator towards the painter and the model towards the canvas; it is this light too, which, washing over the painter, makes him visible to the spectator and turns into golden lines, in the model's eyes, the frame of that enigmatic canvas on which his image, once transported there, is to be imprisoned. This extreme, partial, scarcely indicated window frees a whole flow of daylight which serves as the common locus of the representation. It balances the invisible canvas on the other side of the picture: just as that canvas, by turning its back to the spectators, folds itself in against the picture representing it, and forms, by the superimposition of its reverse and visible side upon the surface of the picture depicting it, the ground, inaccessible to us, on which there shimmers the Image *par excellence*, so does the window, a pure aperture, establish a face as manifest as the other is hidden; as much as the common ground of painter, figures, mod-els, and spectators, as the other is solitary (for no one is looking at it, not even the painter). From the right, there streams in through an invisible window the pure volume of a light that renders all representation visible; to the left extends the surface that conceals, on the other side of its all too visible woven texture, the representation it bears. The light, by flooding the scene (I mean the room as well as the canvas, the room represented on the canvas, and the room in which the canvas stands), envelops the figures and spectators and carries them with it, under the painter's gaze, towards the place where his brush will represent them. But that place is concealed from us. We are observing ourselves being observed by the painter, and made visible to his eyes by the same light that enables us to see him. And just as we are about to apprehend ourselves, transcribed by his hand as though in a mirror, we find that we can in fact apprehend nothing of that mirror but its lustreless back. The other side of a psyche.

Now, as it happens, exactly opposite the spectators—ourselves—on the wall forming the far end of the room, Velázquez has represented a series of pictures; and we see that among all those hanging canvases there is one that shines with particular brightness. Its frame is wider and darker than those of the others; yet there is a fine white line around its inner edge diffusing over its whole surface a light whose source is not easy to determine; for it comes from nowhere, unless it be from a space within itself. In this strange light, two silhouettes are apparent, while above them, and a little behind them, is a heavy purple curtain. The other pictures reveal little more than a few paler patches buried in a darkness without depth. This particular one, on the other hand, opens onto a perspective of space in which recognizable forms recede from us in a light that belongs only to itself. Among all these elements intended to provide representations, while impeding them, hiding them, concealing them because of their position or their distance from us, this is the only one that fulfils its function in all honesty and enables us to see what it is supposed to show. Despite its distance from us, despite the shadows all around it. But it isn't a picture: it is a mirror. It offers us at last

that enchantment of the double that until now has been denied us, not only by the distant paintings but also by the light in the foreground with its ironic canvas.

Of all the representations represented in the picture this is the only one visible; but no one is looking at it. Upright beside his canvas, his attention entirely taken up by his model, the painter is unable to see this looking-glass shining so softly behind him. The other figures in the picture are also, for the most part, turned to face what must be taking place in front—towards the bright invisibility bordering the canvas, towards that balcony of light where their eyes can gaze at those who are gazing back at them, and not towards that dark recess which marks the far end of the room in which they are represented. There are, it is true, some heads turned away from us in profile: but not one of them is turned far enough to see, at the back of the room, that solitary mirror, that tiny glowing rectangle which is nothing other than visibility, yet without any gaze able to grasp it, to render it actual, and to enjoy the suddenly ripe fruit of the spectacle it offers.

It must be admitted that this indifference is equaled only by the mirror's own. It is reflecting nothing, in fact, of all that is there in the same space as itself: neither the painter with his back to it, nor the figures in the centre of the room. It is not the visible it reflects, in those bright depths. In Dutch painting it was traditional for mirrors to play a duplicating role: they repeated the original contents of the picture, only inside an unreal, modified, contracted, concave space. One saw in them the same things as one saw in the first instance in the painting, but decomposed and recomposed according to a different law. Here, the mirror is saying nothing that has already been said before. Yet its position is more or less completely central: its upper edge is exactly on an imaginary line running half-way between the top and the bottom of the painting, it hangs right in the middle of the far wall (or at least in the middle of the portion we can see); it ought, therefore, to be governed by the same lines of perspective as the picture itself; we might well expect the same studio, the same painter, the same canvas to be arranged within it according to an identical space; it could be the perfect duplication.

In fact, it shows us nothing of what is represented in the picture itself. Its motionless gaze extends out in front of that picture, into that necessarily invisible region which forms its exterior face, to apprehend the figures arranged in that space. Instead of surround visible objects, this mirror cuts straight through the whole field of the representation, ignoring all it might apprehend within that field, and restores visibility to that which resides outside all view. But the invisibility that it overcomes in this way is not the invisibility of what is hidden: it does not make its way around any obstacle, it is not distorting any perspective, it is addressing itself to what is invisible both because of the picture's structure and because of its existence as painting. What it is reflecting is that which all the figures within the painting are looking at so fixedly, or at least those who are looking straight ahead; it is therefore what the spectator would be able to see if the painting extended further forward, if its bottom edge were brought lower until it included the figures the painter is using as models. But it is also, since the picture does stop there, displaying only the painter and his studio, what is exterior to the picture, in so far as it is a picture—in other words, a rectangular fragment of lines and colours intended to represent something to the eyes of any possible spectator. At the far end of the room, ignored by all, the unexpected mirror holds n its glow the figures that the painter is looking at (the painter in his represented, objective reality, the reality of the painter at his work); but also the figures that are looking at the painter (in that material reality which the lines and the colours have laid out upon the canvas). These two groups of figures are both equally inaccessible, but in different ways: the first because of an effect of composition peculiar to the painting; the second because of the law that presides over the very existence of all pictures in general. Here, the action of representation consists in bringing one of these two forms of invisibility into the place of the other, in an unstable superimposition—and in rendering them both, at the same moment, at the other extremity of the picture—at that pole which is the very height of its rep-

resentation: that of a reflected depth in the far recess of the painting's depth. The mirror provides a metathesis of visibility that affects both the space represented in the picture and its nature as representation; it allows us to see, in the centre of the canvas, what in the painting is of necessity doubly invisible.

A strangely literal, though inverted, application of the advice given, so it is said, to his pupil by the old Pachero when the former was working in his studio in Seville: 'The image should stand out from the frame.'

II

But perhaps it is time to give a name at last to that image which appears in the depths of the mirror, and which the painter is contemplating in front of the picture. Perhaps it would be better, once and for all, to determine the identities of all the figures presented or indicated here, so as to avoid embroiling ourselves forever in those vague, rather abstract designations, so constantly prone to misunderstanding ad duplication, 'the painter', 'the characters', 'the models', 'the spectators', 'the images'. Rather than pursue to infinity a language inevitably inadequate to the visible fact, it would be better to say that Velázquez composed a picture; that in this picture he represented himself, in his studio or in a room of the Escurial, in the act of painting two figures whom the Infanta Margarita has come there to watch, together with an entourage of *duennas*, maids of honour, courtiers, and dwarfs; that we can attribute names to this group of people with great precision: tradition recognizes that here we have Doña maria Agustina Sarmiente, over there Nieto, in the foreground Nicolaso Pertusato, and Italian jester. We could then add that the two personages serving as models to the painter are not visible, at least directly; but that we can see them in a mirror; and that they are, without any doubt, King Philip IV and his wife, Mariana.

These proper names would form useful landmarks and avoid ambiguous designations; the would tell us in any case what the painter is looking at, and the majority of the characters in the picture along with him. But the relation of language to painting is an infinite relation. It is not that words are imperfect, or that, when confronted by the visible, they prove insuperable inadequate. Neither can be reduced to the other's terms: it is in vain that we say what we see; what we see never resides in what we say. And it is in vain that we attempt to show, by the use of images, metaphors, or similes, what we are saying; the space where they achieve their splendour is not that deployed boy our eyes but that defined by the sequential elements of syntax. And the proper name, in this particular context, is merely and artifice: it gives us a finger to point with, in other words, to pass surreptitiously from that space where one speaks to the space where one looks; in other words, to fold one over the other as though they were equivalents. But if one wishes to keep the relation of language to vision open, if one wishes to treat their incompatibility as a starting-point for speech instead of as an obstacle to be avoided, so as to stay as close as possible to both, then one must erase those proper names and preserve the infinity of the task. It is perhaps through the medium of this grey, anonymous language, always over-meticulous and repetitive because too broad, that the painting may, little by little, release its illuminations.

We must therefore pretend not to know who is to be reflected in the depths of that mirror, and interrogate that reflection in its own terms.

First, it is the reverse of that great canvas represented on the left. The reverse, or rather the right side, since it displays in full face what the canvas, by its position, is hiding from us. Furthermore, it is both in opposition to the window and a reinforcement of it. Like the window, it provides a ground which is common to the painting and to what lies outside it. But the window operates by the continuous movement of an effusion which, flowing from right to left, unites the attentive figures, the painter, and the canvas, with the spectacle they are observing; whereas the mirror, on the other hand, by means of a violent, instantaneous movement, a movement of pure surprise, leaps out from the picture in order to reach that which is observed yet invisible in front of it, and then, at the far end of its fictitious depth, to render it visible yet indifferent to every gaze. The compelling tracer line, joining the reflection to that which it is reflecting,

cuts perpendicularly through the lateral flood of light. Lastly—and this is the mirror's third function—it stands adjacent to a doorway which forms an opening, like the mirror itself, in the far wall of the room. This doorway too forms a bright and sharply defined rectangle whose soft light does not shine through into the room. It would be nothing but a gilded panel if it were not recessed out from the room by means of one leaf of a carved door, the curve of a curtain, and the shadows of several steps. Beyond the steps, a corridor begins; but instead of losing itself in obscurity, it is dissipated in a yellow dazzle where the light, without coming in, whirls around on itself in dynamic repose. Against this background, at once near and limitless, a man stands out in full-length silhouette; he is seen in profile; with one hand he is holding back the weight of a curtain; his feet are placed on different steps; one knee is bent. He may be about to enter the room; or he may be merely observing what is going on inside it, content to surprise those within without being seen himself. Like the mirror, his eyes are directed towards the other side of the scene; nor is anyone paying any more attention to him than to the mirror. We do not know where he has come from: it could be that by following uncertain corridors he has just made his way around the outside of the room in which these characters are collected and the painter is at work; perhaps he too, a short while ago, was there in the forefront of the scene, in the invisible region still being contemplated by all those eyes in the picture. Like the images perceived in the looking-glass, it is possible that he too is an emissary from that evident yet hidden space. Even so, there is a difference: he is there in flesh and blood; he has appeared from the outside, on the threshold of the area represented; he is indubitable—not a probable reflection but an interruption. The mirror, by making visible, beyond even the walls of the studio itself, what is happening in the front of the picture, creates, in its sagittal dimension, an oscillation between the interior an the exterior. One foot only on the lower step, his body entirely in profile, the ambiguous visitor is coming in and going out at the same time, like a pendulum caught at the bottom of its swing. He repeats on the spot, but in the dark reali-

ty of his body, the instantaneous movement of those images flashing across the room, plunging into the mirror, being reflected there, and springing out form it again like visible, new, and identical pieces. Pale, miniscule, those silhouetted figures in the mirror are challenged by the tall, solid stature of the man appearing in the doorway.

But we must move down again from the back of the picture towards the front of the stage; we must leave that periphery whose volute we have just been following. Starting from the painter's gaze, which constitutes an off-centre centre to the left, we perceive first of all the back of the canvas, then the paintings hung on the wall, with the mirror in their centre, then the open doorway, then more pictures, of which, because of the sharpness of the perspective, we can see no more than the edges of the frames, and finally, at the extreme right, the window, or rather the groove in the wall from which the light is pouring. This spiral shell presents us with the entire cycle of representation: the gaze, the palette and brush, the canvas innocent of signs (these are the material tools of representation), the paintings, the reflections, the real man (the completed representation, but as it were freed from its illusory or truthful contents, which are juxtaposed to it); then the representation dissolves again: we can only see the frames, and the light that is flooding the pictures from outside, but that they, in return, must reconstitute in their own kind, as though it were coming from elsewhere, passing through their dark wooden frames. And we do, in fact, see this light on the painting, apparently welling out from the crack of the frame; and from there it moves over to touch the brow, the cheekbones, the eyes, the gaze of the painter, who is holding a palette in one hand and in the other a fine brush... And so the spiral is closed, or rather, by means of that light, is opened.

Our first glance at the painting told us what it is that creates this spectacle-as-observation. It is the two sovereigns. One can sense their presence already in the respectful gaze of the figures in the picture, in the astonishment of the child and the dwarfs. We recognize them, at the far end of the picture, in the two tiny sil-

houettes gleaming out from the looking-glass. In the midst of all those attentive faces, all those richly dressed bodies, they are the palest, the most unreal, the most compromised of all the painting's images: a movement, a little light, would be sufficient to eclipse them. Of all these figures presented before us, they are also the most ignored, since no one is paying the slightest attention to that reflection which has slipped into the room behind them all, silently occupying its unsuspected space; in so far as they are visible, they are the frailest and the most distant form of all reality. Inversely, in so far as they stand outside the picture and are therefore withdrawn from it in an essential invisibility, they provide the centre around which the entire representation is ordered: it is they who are being faced, it is towards them that everyone is turned, it is to their eyes that the princess is being presented in her holiday clothes; from the canvas with its back to us to the Infanta to the dwarf playing on the extreme right, there runs a curve (or again, the lower fork of the X opens) that orders the whole arrangement of the picture to their gaze and thus makes apparent the true centre of the composition, to which the Infanta's gaze and the image in the mirror are both finally subject.

In the realm of the anecdote, this centre is symbolically sovereign, since it is occupied by King Philip IV and his wife. But it is so above all because of the triple function it fulfils in relation to the picture. For in it there occurs and exact superimposition of the model's gaze as it is being painted, of the spectator's as he contemplates the painting, and of the painter's as he is composing his picture (not the one represented, but the one in front of which we are discussing). These three 'observing' functions come together in a point exterior to the picture: that is, an ideal point in relation to what is represented, but a perfectly real one too, since it is also the starting-point that makes the representation possible. Within that reality itself, it cannot be invisible. And yet, that reality is projected within the picture—projected and diffracted in three forms which correspond to the three functions of that ideal and real point. They are: on the left, the painter with his palette in his hand (a self-portrait of Velázquez); to the right, the visitor, one foot on the step, ready to enter the room; he is taking in the scene from the back, but he can see the royal couple, who are the spectacle itself, from the front; and lastly, in the centre, the reflection of the king and the queen, richly dressed, motionless, in the attitude of patient models.

A reflection that shows us quite simply, and in shadow, what all those in the foreground are looking at. It restores, as if by magic, what is lacking in every gaze: in the painter's, the model, which his represented double is duplicating over there in the picture; in the king's, his portrait, which is being finished off on that slope of the canvas he cannot perceive from where he stands; in that of the spectator, the real centre of the scene, whose place he himself has taken as though by usurpation. But perhaps this generosity on the part of the mirror is feigned; perhaps it is hiding as much as and even more than it reveals. That space where the king and his wife hold sway belongs equally well to the artist and to the spectator: in the depths of the mirror there could also appear—there ought to appear—the anonymous face of the passer-by and that of Velázquez. For the function of that reflection is to draw into the interior of the picture what is intimately foreign to it: the gaze which has organized it and the gaze for which it is displayed. But because they are present within the picture, to the right and to the left, the artist and the visitor cannot be given a place in the mirror: just as the king appears in the depths of the looking-glass precisely because he does not belong to the picture.

In the great volute that runs around the perimeter of the studio, from the gaze of the painter, with his motionless hand and palette, right round to the finished paintings, representation came into being, reached completion, only to dissolve once more into the light; the cycle was complete. The lines that run through the depth of the picture, on the other hand, are not complete; they all lack a segment of their trajectories. This gap is caused by the absence of the king—an absence that is an artifice on the part of the painter. But this artifice both conceals and indicates another vacancy which is, on the contrary, immediate: that of the painter and the spectator when they are looking at or composing the picture. It may be that, in this picture, as in all the representations of which

it is, as it were, the manifest essence, the profound invisibility of what one sees is inseparable from the invisibility of the person seeing—despite all mirrors, reflections, imitations, and portraits. Around the scene are arranged all the signs and successive forms of representation; but the double relation of the representation to its model and to its sovereign, to its author as well as to the person to whom it is being offered, this relation is necessarily interrupted. It can never be present without some residuum, even in a representation that offers itself as a spectacle. In the depth that traverses the picture, hollowing it into a fictitious recess and projecting it forward in front of itself, it is not possible for the pure felicity of the image ever to present in a full light both the master who is representing and the sovereign who is being represented.

Perhaps there exists, in this painting by Velázquez, the representation, as it were, of classical representation, and the definition of the space it opens up to us. And, indeed, representation undertakes to represent itself here in all its elements, with its images, the eyes to which it is offered, the faces it makes visible, the gestures that call it into being. But there, in the midst of this dispersion which it is simultaneously grouping together and spreading out before us, indicated compellingly from every side, is an essential void: the necessary disappearance of that which is its foundation—of the person it resembles and the person in whose eyes it is only a resemblance. This very subject—which is the same—has been elided. And representation, freed finally from the relation that was impeding it, can offer itself as representation in its pure form.

Concise Bibliography

Beruete y Moret, Aureliano de. *Velazquez in the Prado Museum.* Barcelona: J. Thomas, 1914.

Brown, Jonathan. *Velázquez: Painter and Courtier.* New Haven: Yale University Press, 1988.

Brown, Jonathan, and Carmen Garrido. *Velázquez: The Technique of Genius.* New Haven: Yale University Press, 2003.

Davies, Randall. *Velasquez.* London: A. and C. Black, 1914.

Gudiol, Jose. *Complete Paintings of Velázquez.* Random House, 1983.

Hind, C. Lewis. *Days with Velásquez.* London: A. and C. Black, 1906.

Justi, Carl. *Diego Velazquez and His Times.* Philadelphia: J.B. Lippincott Co., 1889.

López-Rey, José. *Velázquez: Catalogue Raisonné.* Cologne: Taschen Verlag, 1996.

Ortiz, Antonio Domiguez. *Velázquez.* New York: Harry N. Abrams, 1990.

Piper, David. *Velázquez: Every Painting.* New York: Rizzoli International Publications, 1980.

Prater, Andreas. *Venus at Her Mirror: Velazquez and the Art of Nude Painting.* New York: Prestel, 2002.

Stevenson, Robert Alan Mowbray. *Velasquez.* London: G. Bell, 1906.

Stratton-Pruitt, Suzanne. *Velázquez's "Las Meninas."* Cambridge: Cambridge University Press, 2002.

Tinterow, Gary. *Manet/Velázquez: The French Taste for Spanish Painting.* New York: Metropolitan Museum of Art, 2003.

Wolf, Norbert. *Diego Velázquez: 1599–1660.* Cologne: Taschen Verlag, 2000.